POSTCARD HISTORY SERIES

BRISTOL

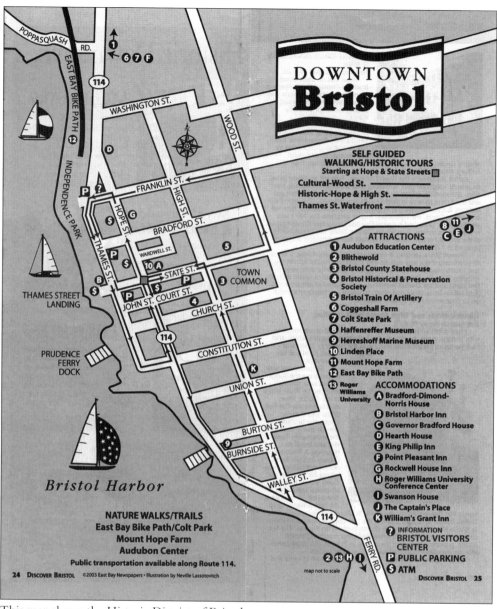

This map shows the Historic District of Bristol.

POSTCARD HISTORY SERIES

BRISTOL

Richard V. Simpson

Copyright © 2005 by Richard V. Simpson
ISBN 0-7385-3921-X

Published by Arcadia Publishing
Charleston SC, Chicago IL, Portsmouth NH, San Francisco CA

Printed in Great Britain

Library of Congress Catalog Card Number: 2005931664

For all general information contact Arcadia Publishing at:
Telephone 843-853-2070
Fax 843-853-0044
E-mail sales@arcadiapublishing.com
For customer service and orders:
Toll-Free 1-888-313-2665

Visit us on the Internet at http://www.arcadiapublishing.com

Other Books by Richard V. Simpson
Bristol, Rhode Island (1996)
Bristol, Rhode Island: Volume II (1998)
America's Cup Yachts: The Rhode Island Connection (1999)
Building the Mosquito Fleet: U.S. Navy's First Torpedo Boats (2001)
Bristol: Montaup to Poppasquash (2002)

Books by Richard V. Simpson and Nancy J. Devin
Portsmouth, Rhode Island (1997)
Tiverton and Little Compton, Rhode Island (1997)
Tiverton and Little Compton Volume II (1998)

On the cover: Sitting quietly under the northern side of the Mount Hope Bridge, the Federal Revival–style Bristol Ferry Lighthouse was commissioned in 1855 to light the narrow passage between Mount Hope Bay and Narragansett Bay. In 1916, the light's original wooden lantern was upgraded to an iron one that was originally used in a Hudson River lighthouse. The light was also raised six feet from its original height of 28 feet. In 1927, the light was replaced by an automated light, which was then made obsolete just three years later due to construction of the Mount Hope Bridge and subsequent discontinuation of the ferry service that connected the East Bay to Aquidneck Island. In 1928, the government removed the lighthouse's light and the property was sold. The lighthouse began a new incarnation as a residence and has remained in private hands since.

CONTENTS

There's some high-class boys in Bristol, R.I. What do you think of this one?

During the 325-plus years of Bristol, Rhode Island's existence, its identity has been recognized around the world. Wherever the town's motto, "Ship shape 'n' Bristol Fash'n" is uttered, the listener instinctively knows which Bristol (of the world's many) the speaker is referring. Throughout the 18th and 19th centuries, Bristol ships carried homegrown agricultural products to nearby American ports and to the far West Indies. Bristol-built ships were sturdy and fast and the town's produce was fresh and wholesome upon delivery.

INTRODUCTION

The town of Bristol is situated in the Mount Hope Lands of the Pokanoket Wampanoag tribe of Native Americans who controlled all the land between Narragansett Bay east to Massachusetts Bay. In 1666, Wampanoag Chief Sachem Metacomet, known as King Philip, was feeling the pressure of the colonists who surrounded his Mount Hope Lands. In an effort to halt the advance of the white settlers, Philip began to prepare for war by uniting tribes to the north and west; tribes that had been enemies for centuries. During the ensuing bloody conflict, Philip's warriors burned over 600 colonists' buildings and took the lives of hundreds of settlers in retaliation for atrocities committed upon his people by the whites. After a relentless pursuit, Captain Benjamin Church and his army of English and American Indians (who had converted to Christianity) trapped and killed Philip at his refuge of last resort, Mount Hope.

With the defeat of the last of the native residents, the town's natural harbor was ripe for a growing shipping industry. By 1690, seventy families were settled in the area and Bristol, part of Plymouth Colony, became the home port for 15 ships. Since the settlers had little raw materials for export, they became predominantly an agricultural-based shipping town. The harbor became the focal point of life in the town.

During the American Revolution, Bristol suffered from British blockades of shipping and the enforcement of burdensome taxation of imports. In October 1775, British ships sailed into Bristol Harbor demanding provisions. When town fathers denied the demand, the British fleet began an unmerciful bombardment of the village. The cannonade caused little structural damage, but did manage to severely frighten the townsfolk who were not accustomed to such aggression.

In 1778, some 500 British and Hessian troops marched into Bristol from Warren and put the torch to over 30 buildings known to belong to prominent Americans who were sympathetic to the cause of Independence.

With the successful conclusion of the Revolutionary War, and with relative peace and quiet, a resurgence of the shipping industry drew Bristol merchants off the coast to extend their trade to the West Indies (Caribbean) and Africa. With new wealth from the boom in the commercial shipping industry, Bristol became a pivotal point in the nefarious slave trade.

Bristol sent out several privateers (functioning as legal pirate ships) during the War of 1812. Most of these piratical cruises were very successful and added greatly to the town's riches. The brig *Yankee*, a terror to the commerce of John Bull, but a gold-mine in prize-money to her sailors and owners, was phenomenally successful and made six cruises in all, bringing much British treasure home to Bristol.

In 1825, laws were enacted to make the slave trade illegal; but this is not to suggest that certain Bristol traders did not continue to pursue the risky business. Around the same time, loss of the celebrated triangle trade upon which the town was dependent caused an economic depression. Merchants and tradesmen began looking for other means of livelihood.

As shipping declined, Bristol grasped hold of the Industrial Revolution and put to work the energy of the steam turbine. The little town once again moved within the circles of prosperity; textile manufactories and sugar refineries sprung up.

From 1825 until about 1850, the whaling industry was carried on to a considerable extent. At one time 34 vessels were engaged in this business. The West India trade continued to flourish until 1865, at which time it almost wholly ceased.

In 1857, Bristol was connected with Providence by rail, and in 1867 a line of steam ferryboats was established between Bristol and New York. The steamers *Bristol* and *Providence* were built and operated expressly for this line by the Rhode Island Street Railroad Company and run by it until transferred to the Fall River Line in 1869.

Bristolians engaged in various manufacturing industries throughout the town's three centuries of existence. The earliest manufactured product that we have knowledge of is malt liquors, which were distilled in 1681 in a Chestnut Street brewery operated by John Cory.

This was followed by various other manufactories of malt liquors and rum, until about 1830, when this line of business wholly ceased. Several gristmills operated in the town, some operated by tidal dams and others by wind power. The oldest mill of which there is a record was built by Joseph Reynolds sometime before 1700 on Bristol Neck. After 20 years, the mill was moved further south to the place at the head of the harbor that is still called Windmill Point.

Two other industries that employed many residents were boat building and chandlery. Steamships were built on several wharfs and yards. During the 1830s through 1850s some 60 large commercial vessels were built and rigged here. The Herreshoff brothers began to design and build the winning America's Cup Defenders that were destined to bring fame to the Herreshoff family and to Bristol. From the late 1800s until the mid-1940s, the Herreshoff Manufacturing Company became world renowned for its production of revolutionary designs for America's Cup racing yachts, steam yachts, as well as steel service vessels and high speed torpedo boats for the U.S. Navy.

At the outbreak of the Spanish-American War in 1898, the Herreshoff Manufacturing Company was building the U.S. Navy's first all steel sea-going torpedo boats. The Bristol Naval Reserve Torpedo Company took an active part in wartime preparedness by identifying locally owned yachts and cargo vessels suitable to move troops and supplies.

In the 1800s, the town's largest employer became the National India Rubber Company, a producer of rubberized clothing, boots, and shoes. At its peak, the NIRC employed over 4,000 people. By 1918, huge demand for its products pushed the production of rubber shoes and boots to a daily output of 53,000 pairs. Plants manufacturing rubber goods, cotton cloth, rifles, whale oil, sugar refinery, and steam and sail yachts sprung up.

The casual historian thumbing through my 1996 and 1998 Bristol pictorials in Arcadia's Images of America series will see period photographs of these properties, a collection of five ramshackle buildings on 1.7 acres, that once formed a bustling commercial nucleus. The area contained a lumberyard, wharves, a bank, and warehouses built as early as 1797. Formerly known as DeWolf Wharf, the area was, for decades, the center of Thames Street commerce and trade.

A trio of businessmen has turned the former J. T. O'Connell and Gilbert's Seafood properties into Thames Street Landing. The partners have restored the old time flavor to the property—they have brought back its original character. All five building have returned to their late-18th century charm, and an additional three new buildings have been built in a complementary architectural style.

It is my sincere hope that you enjoy this pictorial jaunt through recent Bristol history. As satisfying as the research and assembling of these facts and images may be to me, it is a wasted effort if the results are not imparted to others who may have a similar interest. Propagation is the responsibility of the social historian.

One

Great Houses of the
Great Folks

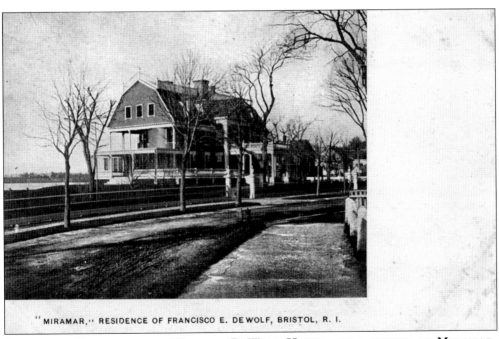

"MIRAMAR," RESIDENCE OF FRANCISCO E. DEWOLF, BRISTOL, R. I.

SOUTHEAST FRONT OF THE WILBOUR-DEWOLF HOUSE, ALSO KNOWN AS MIRAMAR, AND THE TIDES. Set on Bristol Harbor, this large, two-and-a-half-story, hip-roof summer cottage with cross-gambrel roof was designed by E. I. Nickerson for Sen. Joshua Wilbour in 1893. This view of the Hope Street façade is ornamented with wraparound porches, a large porte cochere with Ionic columns, pilasters, an over-scale lunette in the attic, quoins, and a modillion cornice.

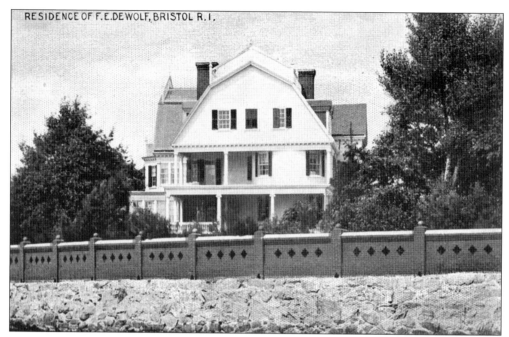

THE WILBOUR-DeWOLF HOUSE WEST FRONT WITH PANORAMIC VIEWS OF BRISTOL HARBOR. The 1938 hurricane destroyed the roof balustrade and large urn-topped fence posts.

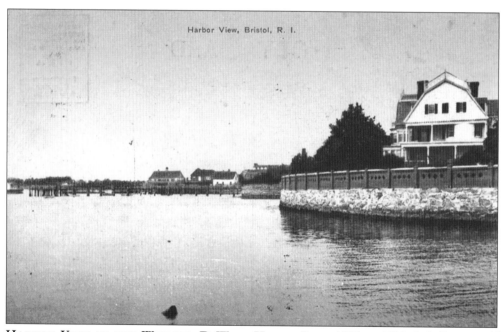

HARBOR VIEW OF THE WILBOUR-DeWOLF HOUSE. From 1900 to 1936, Isabella DeWolf owned Miramar. In the early 1970s, it was remodeled into apartments, and in 1986 the house was converted to condominiums.

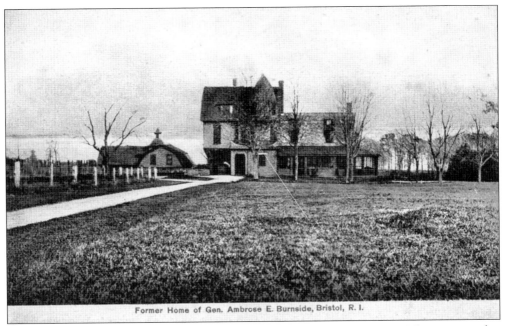

Former Home of Gen. Ambrose E. Burnside, Bristol, R. I.

WEST FRONT OF THE FORMER HOME OF GEN. AMBROSE E. BURNSIDE. The property that later became Ferrycliffe Farm, built around 1880, and is now the campus of Roger Williams University, rambles down to the shore of Mount Hope Bay.

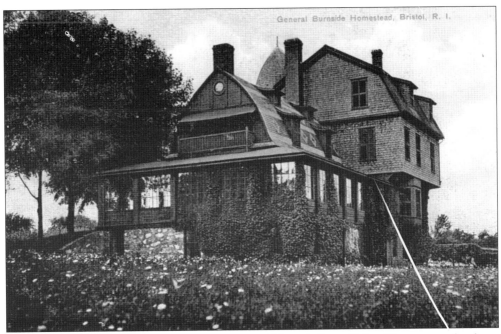

General Burnside Homestead, Bristol, R. I.

SOUTHEAST VIEW OF THE BURNSIDE HOUSE. Although Burnside's military career has been severely criticized, as a citizen of Bristol he was found to be courtly in his manners, scrupulously neat in his attire, and somewhat punctilious in matters of etiquette. Acquaintances among his farmer neighbors found him cordial, friendly, and at times jocular in his relations with them.

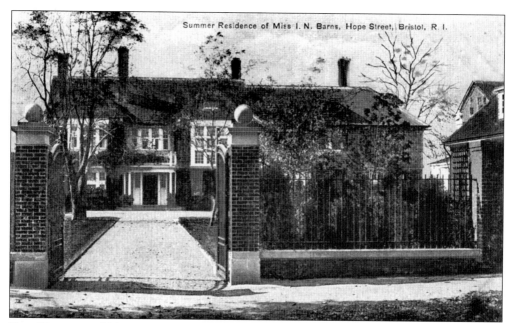

Summer Residence of Miss I. N. Barns, Hope Street, Bristol, R. I.

THE HOUSE AT 221 HOPE STREET. Isoline and Hattie Barnes built this large, Queen Anne summerhouse, designed by Wallis E. Howe in 1899. The two-and-a-half-story structure with a complex cross-gable roof and an offset hip-roof wing, has been compromised by the addition of a modern wing on the north side. The house and grounds were willed to Wallis E. Howe in 1935. In the 1960s, the building was owned by his son George Howe.

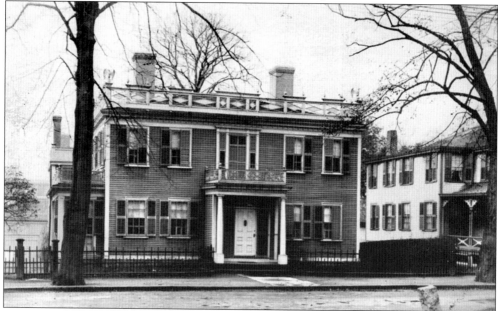

JOHN HOWE HOUSE AND FOUR EAGLES. Howe, a grandson of Mark Antony DeWolf built this two-story, five bay, nearly square Federal house around 1808, noted for its Chinese Chippendale roof balustrade. Capt. Benjamin Churchill, master of the privateer brigantine *the Yankee*, bought the house in 1822. Traditionally, it is believed that *the Yankee*'s sailors carved the four American eagles that trim the corners of the balustrade.

THE DIRT SIDEWALK AND STURDY STONEWALL ALONG FERRY ROAD. This wall marks the eastern boundary of the Blithewold estate. With its provincial charm preserved, the walkway remains very much the same as in this *c.* 1900 photo postcard.

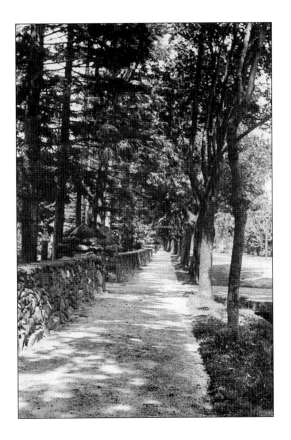

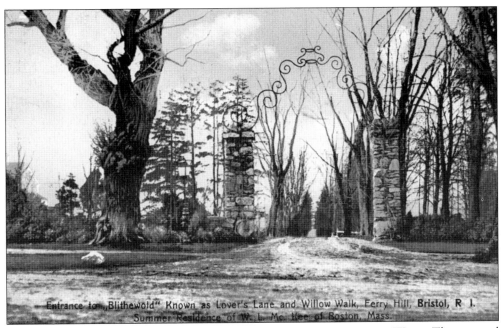

Entrance to "Blithewold" Known as Lover's Lane and Willow Walk, Ferry Hill, Bristol, R I. Summer Residence of W. L. Mc Kee of Boston, Mass.

ENTRANCE TO BLITHEWOLD, KNOWN AS LOVER'S LANE AND WILLOW WALK. The unpaved road terminates at the water with sweeping views of Bristol Harbor.

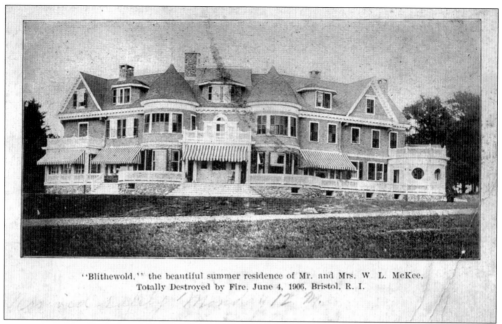

"Blithewold." the beautiful summer residence of Mr. and Mrs. W. L. McKee,
Totally Destroyed by Fire. June 4, 1906, Bristol, R. I.

WEST FRONT BLITHEWOLD-VANWICKLE-MCKEE HOUSE. Augustus VanWickle, a Pennsylvania coal magnate, purchased the property from John Rogers Gardner in 1894 after visiting Bristol as a guest of John Brown Herreshoff. He built the massive Victorian summer cottage in 1895. The mansion was destroyed by fire on June 4, 1906.

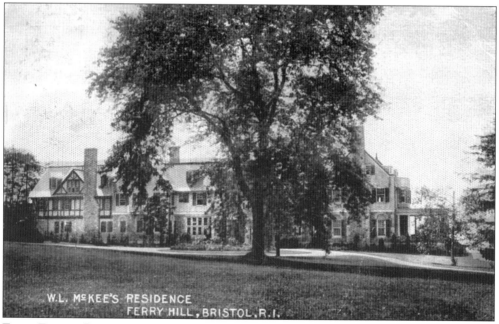

W.L. McKEE'S RESIDENCE
FERRY HILL, BRISTOL, R.I.

EAST FRONT BLITHEWOLD-VANWICKLE-MCKEE HOUSE. VanWickle died in 1898. His widow married William L. McKee, a Boston shoe manufacturer, in 1901. After the original house was destroyed, the McKees built the present house combining Tudor and Classical Revival elements.

14

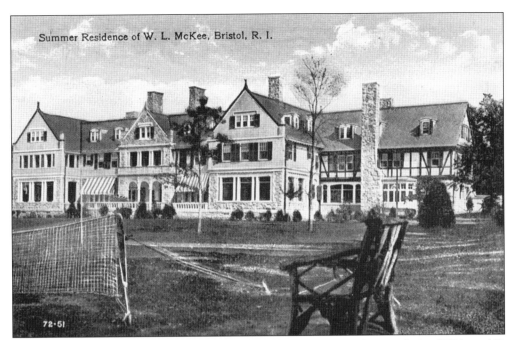

Summer Residence of W. L. McKee, Bristol, R. I.

72-51

BLITHEWOLD–MCKEE HOUSE. This *c.* 1916 postcard image shows the west front of Blithewold's massive façade. On this west or water side, the gables on each end incorporate engaged porches on both levels, which were designed to take advantage of the sea breezes off of Bristol Harbor.

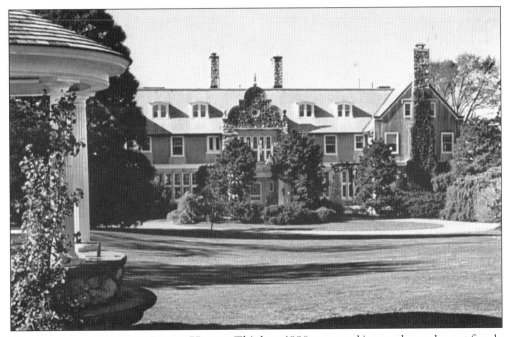

BLITHEWOLD–MARJORIE LYONS HOUSE. This late-1990s postcard image shows the east façade with its central gable of rubble stone rising above the main entrance, which is sheltered by a wood and stone porte-cochere with Ionic detailing.

15

BLITHEWOLD-LYONS HOUSE. The historic landscape of Blithewold reflects the natural landscape tradition of the Victorian-era in its combination of large lawns with groupings of specimen trees and shrubs, the use of formal gardens near the house, and perennial beds along paths. Through the bequest of Marjorie VanWickle Lyons to the Heritage Trust of Rhode Island, the estate is known as the Blithewold Gardens and Arboretum.

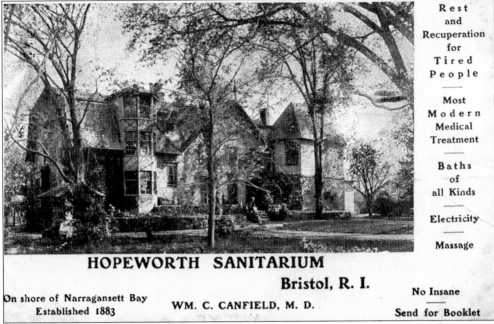

DR. WILLIAM CANFIELD'S HOPEWORTH SANITARIUM. Located in the Hopeworth section, called the Middle District, this was not the same kind of sanitarium as we are familiar with today. Dr. Canfield's clinic was more of a rest home in the nature of the Betty Ford Clinic, for the cure of drug and alcohol dependence. The sanitarium building was a 44-room Victorian Gothic; it was built around 1906, deep in the woods, on Canfield's 65-acre estate.

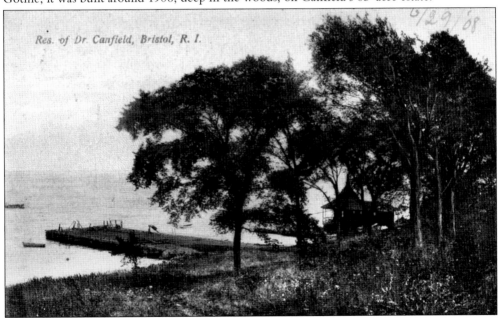

Res. of Dr. Canfield, Bristol, R. I.

HOPEWORTH SANITARIUM WATER FRONT. At the beginning of the 20th century, the Hopeworth section of town consisted of many very large dairy farms and gentlemen farmers' country estates stretching from the Back Road, now called Metacom Avenue (route 136), to the shore of Mount Hope Bay.

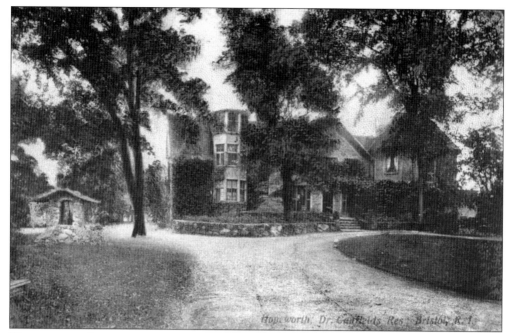

HOPEWORTH SANITARIUM EAST FRONT. Far away from the bustle of busy Bristol center and the temptations of the many Thames Street pubs, Dr. Canfield's patients had countless opportunities for sober rest, relaxation, and contemplation. The spacious grounds of the sanitarium offered a variety of natural surroundings for the lover of nature: woods, fields, marshes, and the bay.

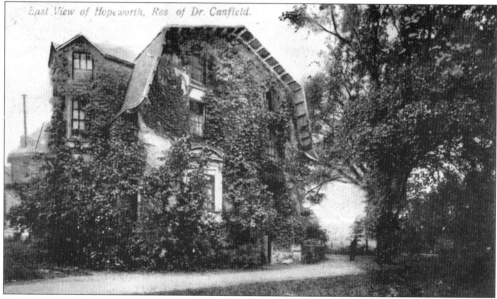

HOPEWORTH SANITARIUM NORTH VIEW. In the first half of the 1900s, many of the large farms and summer residences of the wealthy, in the new Hopeworth Estates, were subdivided into smaller plats for housing. With the advent of modern medicine, Dr. Canfield's sanitarium became redundant and was closed. On November 2, 1959, the vacant residence and sanitarium was destroyed by fire.

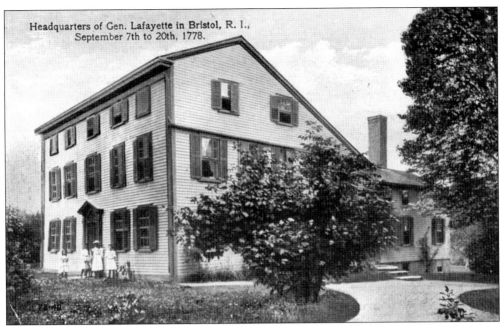

Headquarters of Gen. Lafayette in Bristol, R. I.,
September 7th to 20th, 1778.

THE JOSEPH REYNOLDS HOUSE. Records show that this unique, early transitional Massachusetts-plan house was built by Reynolds on the ten-acre lot that his father, Nathaniel Reynolds, a leather worker from Boston, purchased in 1684. In 1778, Gen. Marquis de Lafayette used this house as his headquarters. The house was designated a National Historic Landmark in 1982.

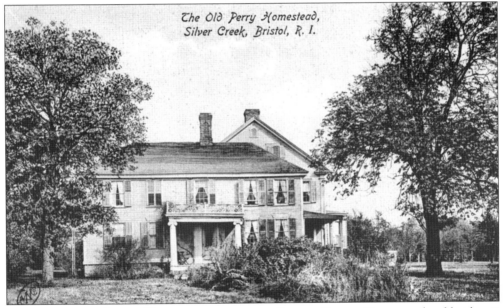

The Old Perry Homestead,
Silver Creek, Bristol, R. I.

THE BOSWORTH-PERRY HOUSE ALSO KNOWN AS SILVER CREEK. Known as the oldest house in Bristol, this structure was started by Deacon Nathaniel Bosworth in 1683, who conducted the town's first Congregational meetings here. Now gone are the Greek Revival piazza with Chinese Chippendale balustrade, and the Victorian-era gardens to the east and north. Bereft of its setting, it is still an important architectural and historical landmark.

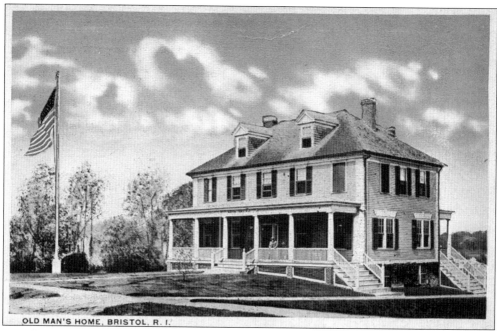

OLD MAN'S HOME, BRISTOL, R. I.

BENJAMIN CHURCH HOME FOR AGED MEN AND SENIOR CENTER. The home was designed to provide pleasant housing in a rural environment for aged men and later for aged women. It was opened May 1908, and continued to operate until 1966 when trustees granted the 11.5-acre site and building to the Bristol Housing Authority. Since 1972, the house has been renovated in four stages into a senior citizen center.

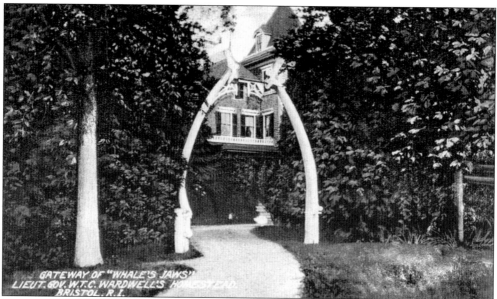

GATEWAY OF "WHALE'S JAWS"
LIEUT. GOV. W.T.C. WARDWELL'S HOMESTEAD.
BRISTOL, R. I.

THE GATEWAY TO "WHALE'S JAWS," THE BRISTOL ESTATE OF LIEUTENANT GOVERNOR W. T. C. WARDWELL. The property is on the east side of Metacom Avenue (route 136) directly across from the intersection of Bay View Avenue. The property was purchased by Richard Algeria, where he subsequently built his King Philip Inn, apartment complex, and strip mall.

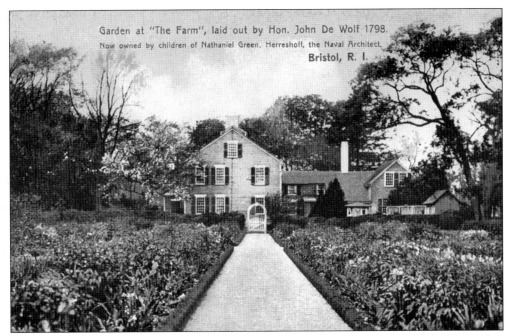

Garden at "The Farm", laid out by Hon. John De Wolf 1798. Now owned by children of Nathaniel Green. Herreshoff, the Naval Architect. Bristol, R. I.

JOHN DEWOLF HOUSE. Known simply as the Farm, this two-story, five-bay, gable roofed, Federal farmhouse was built in three sections (1787, 1798, and around 1900). After the Revolution, John DeWolf (1760–1841) gradually acquired land on both sides of Griswold Avenue until his farm stretched from Bristol Harbor to Mount Hope Bay. Housewright Simeon Pierce charged $225 for construction and material used.

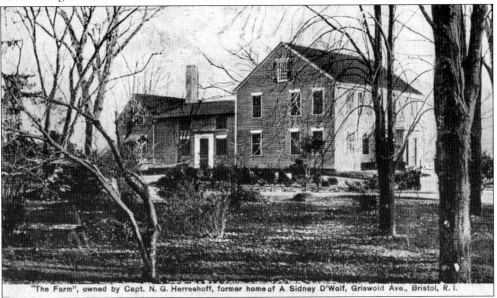

"The Farm", owned by Capt. N. G. Herreshoff, former home of A Sidney D'Wolf, Griswold Ave., Bristol, R. I.

DEWOLF-HERRESHOFF HOUSE. In 1862, the farm passed to John James DeWolf and A. Sidney DeWolf. John received the land west of Ferry Road (including the sites of Blithewold, St. Columban Monastery, and Wind Hill). Sidney inherited the land east of the road to Mount Hope Bay along with this house. Sidney's daughter Clara married Nathanael Greene Herreshoff; the Herreshoffs lived here until Clara's death in 1905.

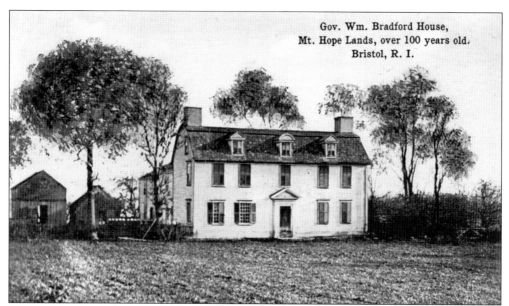

Gov. Wm. Bradford House,
Mt. Hope Lands, over 100 years old,
Bristol, R. I.

MOUNT HOPE FARM. Built in three stages (around 1745, around 1840, and around 1914), the two-and-a-half-story, five-bay, gambrel-roof main section of this house has a two-room plan with a central hall. The house and lands have a long and interesting history. The property was confiscated by the state after Isaac Royall, a loyalist, fled to Nova Scotia in 1776. In the 1950s, some 220 acres, including historic Mount Hope, were deeded to Brown University.

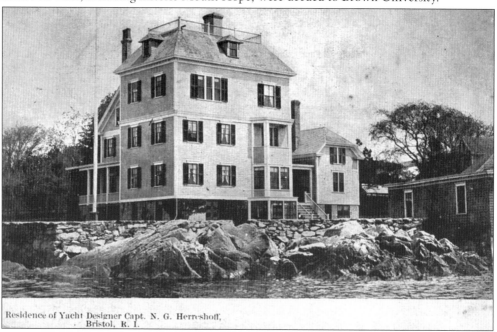

Residence of Yacht Designer Capt. N. G. Herreshoff,
Bristol, R. I.

LOVE ROCKS, BUILT C. 1880. After his wife Clara's death in 1905, Nathanael Greene Herreshoff moved into his parents' house, built on a small piece of land that juts out into Bristol Harbor. The rocky ledge upon which the house sits was known for generations as Love Rocks, thus the house quite naturally was called by that name. From this Hope Street house, Captain Nat had a two minute walk to the Herreshoff shops.

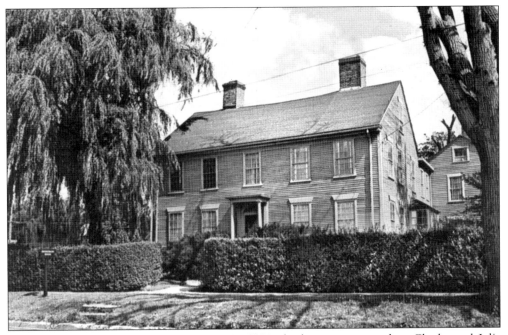

THE RICHMOND-HERRESHOFF HOUSE. In 1856, the house was rented to Charles and Julia Herreshoff, who moved here with nine children from their Point Pleasant Farm on Poppasquash. Julia purchased the house in 1863. In 1893, Louis Herreshoff and Sally Brown (née Herreshoff) owned the homestead. Lewis died in 1923 and left the property to his nephew Norman F. Herreshoff.

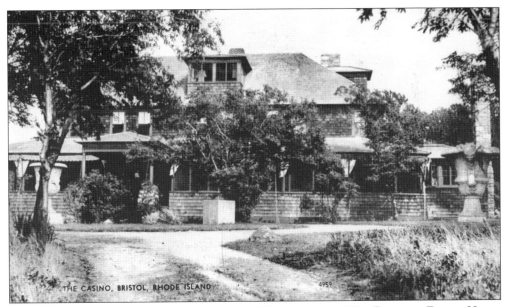

THE CASINO; COL. S. P. COLT'S SUMMER HIDEAWAY ON HIS BRISTOL FARM. Henry Paquin, a violinist, sometimes hired by Colonel Colt to entertain his guests at the Casino, told stories about the "wild and decadent" parties thrown there with "New York show girls." After the state purchased the 466-acre farm in 1965, the casino was razed due to a lack of funds to restore it.

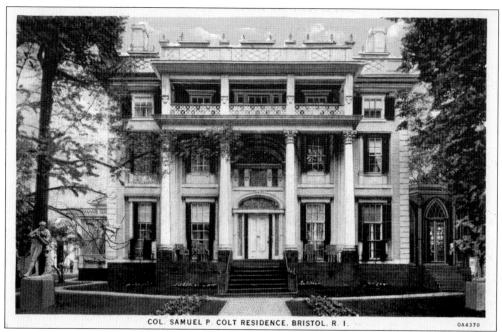

COL. SAMUEL P. COLT RESIDENCE, BRISTOL, R. I.

0A4370

LINDEN PLACE: THE GENERAL GEORGE DEWOLF–COLONEL SAMUEL P. COLT HOUSE, BUILT 1810. This is a Russell Warren–designed and built house. Of the many elegant homes built for the Bristol DeWolfs, this is the only one remaining. In 1988, the voters of the state of Rhode Island approved a $1.5 million bond to help purchase Linden Place and restore it for use as a cultural and educational center.

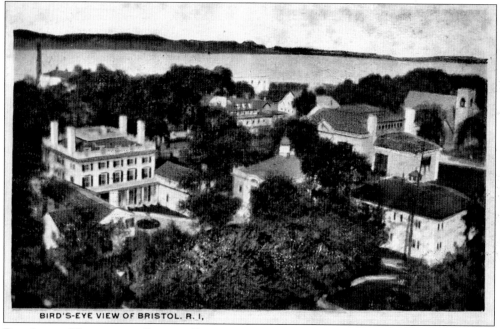

BIRD'S-EYE VIEW OF BRISTOL, R. I.

BIRD'S-EYE VIEW OF THE LINDEN PLACE COMPOUND. This photo was taken from the tower of the State Street Methodist Church. Bristol Harbor is in the upper background, the Trinity Episcopal Church is in the extreme right, and Colt Memorial School (1906) is just below that.

24

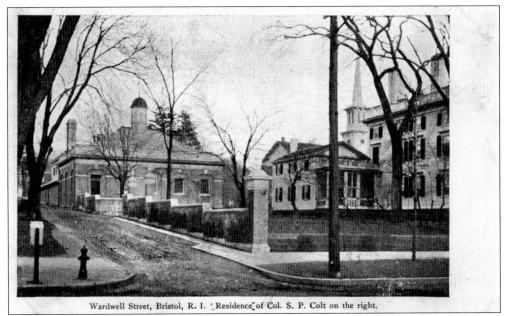

Wardwell Street, Bristol, R. I. Residence of Col. S. P. Colt on the right.

WARDWELL STREET, NORTH SIDE OF LINDEN PLACE, C. 1915. Colt enlarged the site and built the adjacent Howe-designed ballroom in 1905. Howe's design called for relocation of the two-story, wood carriage house (c. 1850), construction of a two-story, yellow brick garage and chauffeur's quarters and a yellow brick wall along Wardwell Street to define the northern property line.

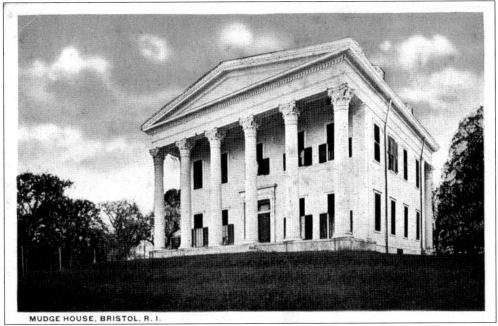

MUDGE HOUSE, BRISTOL, R. I.

MARK ANTONY DEWOLF-MUDGE MANSION, BUILT C. 1890. This mansion was the last of the four great DeWolf houses to be designed by Russell Warren. Set on a small rise on the Poppasquash shore, it dominated the vista from the town side of Bristol Harbor. The property descended to the Mudge family. The mansion burned on Sunday morning, October 19, 1919.

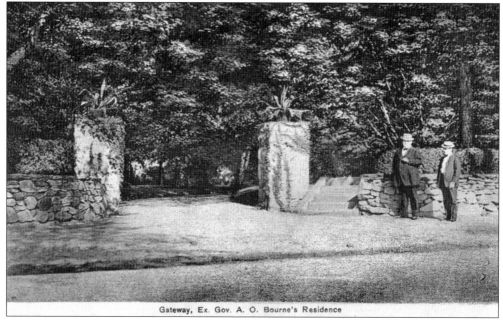

Gateway, Ex. Gov. A. O. Bourne's Residence

THE HOPE STREET ENTRANCE TO SEVEN OAKS, THE AUGUSTUS O. BOURN ESTATE.
The Gothic Revival mansion was designed by famed New York architect James Renwick for Augustus Bourn in 1873. Bourn was founder of the National India Rubber Company (1864), and was Rhode Island's governor (1883).

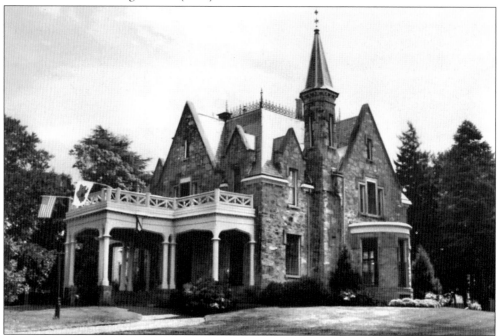

SEVEN OAKS, THE AUGUSTUS O. BOURN ESTATE. This is a large, hip-and-cross-gable-roof, Gothic Revival mansion with twin turrets, iron roof creating, and a large porte-cochere on the north with clustered, square columns and a roof balustrade. The stone walls of this magnificent structure are soft gray.

Two

Bristol Ferry Light and Mount Hope Bridge

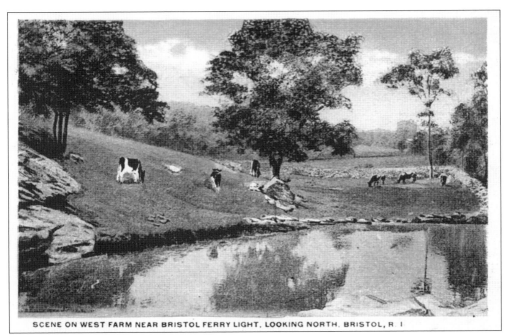

SCENE ON WEST FARM NEAR BRISTOL FERRY LIGHT, LOOKING NORTH, BRISTOL, R. I

Capt. William H. West Farm. This farm was situated at the confluence of Narragansett Bay and Mount Hope Bay at Bristol Ferry. Captain West was a deep-water sailor who operated a two horse–powered treadmill ferry over the mile that separated Bristol from Aquidneck Island.

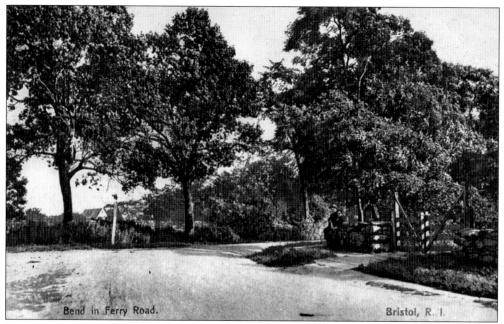

Bend in Ferry Road. Bristol, R. I.

THE BEND IN FERRY ROAD AT THE INTERSECTION OF WOOD AND HOPE STREETS. Ferry Road from this point ran south, dividing the bucolic farms of John James DeWolf and A. Sidney DeWolf, down to the Bristol Ferry landing.

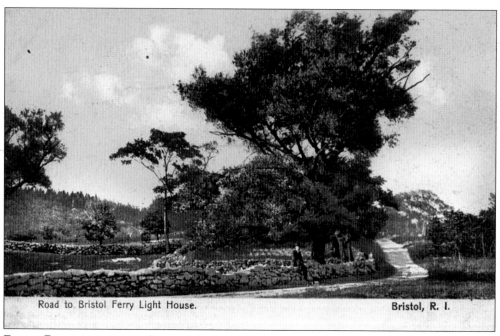

Road to Bristol Ferry Light House. Bristol, R. I.

FERRY ROAD ALONG THE STONE FENCE OF WEST FARM. At this point in the road there is a sweeping panorama of Mount Hope Bay, the ferry, and Portsmouth's Narragansett Bay shore.

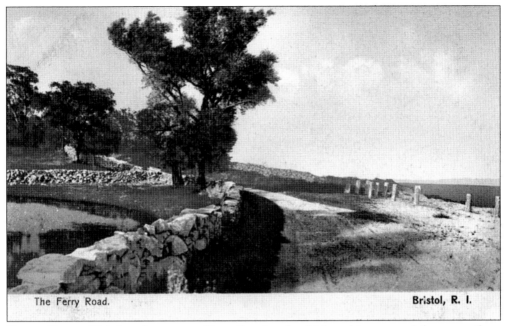

The Ferry Road. Bristol, R. I.

FERRY ROAD. This is a view east on Ferry Road at the tidal pool just around the corner from the Bristol Ferry Light.

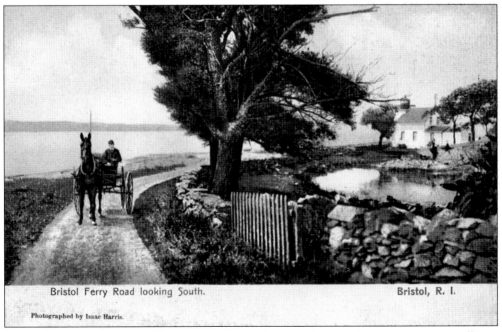

Bristol Ferry Road looking South. Bristol, R. I.

Photographed by Isaac Harris.

FERRY ROAD NEAR THE CONFLUENCE OF MOUNT HOPE AND NARRAGANSETT BAYS. This image is of Ferry Road, showing the view west to the Bristol Ferry Lighthouse.

29

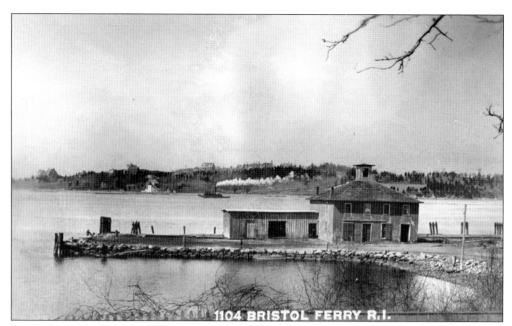

Bristol Ferry Station on the Portsmouth Shore. In the distance is the Bristol shore and the Bristol Ferry Lighthouse. In 1985, the 150-year-old ferry station, abandoned for two years, was torched by vandals and destroyed.

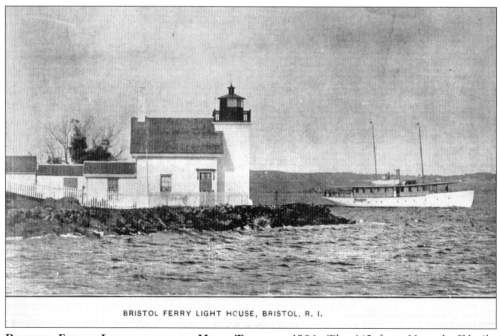

BRISTOL FERRY LIGHT HOUSE, BRISTOL, R. I.

Bristol Ferry Lighthouse at High Tide, c. 1906. The 162-foot, Herreshoff-built, diesel-driven cruiser is the *Ara*; she was built for E. B. Dane.

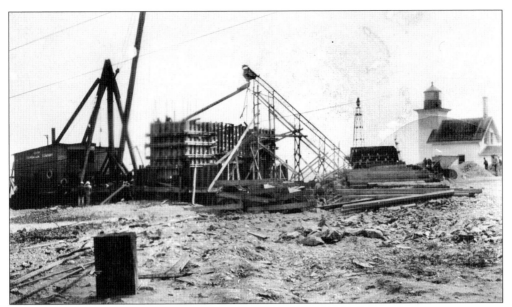

MOUNT HOPE BRIDGE. The soon to be obsolete Bristol Ferry Lighthouse broods in the near background as frames for the bridge's piers are built. From the earliest human habitation, crossing the narrow water gap between Mount Hope and Aquidneck Island was accomplished by ferry. In 1926, the Mount Hope Bridge Commission was formed to study the feasibility of replacing the ferry service.

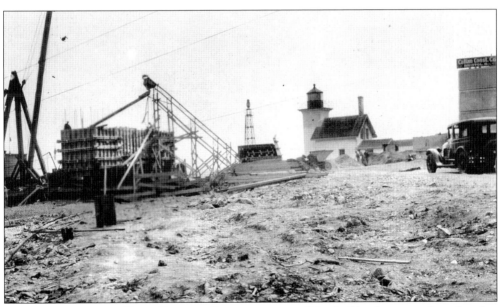

BEGINNING MOUNT HOPE BRIDGE CONSTRUCTION. Rhode Island voters rejected a plan for a cantilevered bridge, designed to provide a future second deck. Subsequently the private Mount Hope Bridge Company was formed. In 1927, the company awarded David B. Steinman of Robinson and Steinman of New York a contract to design a wire-cable suspension bridge at a projected cost of $3 million.

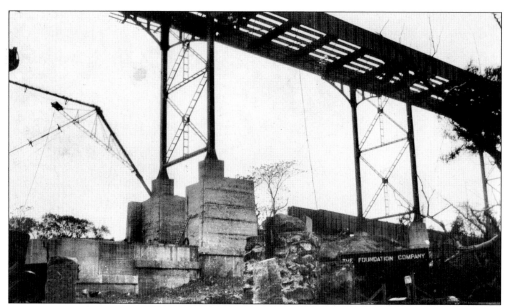

DECKING THE MOUNT HOPE BRIDGE. A little known fact about the bridge construction concerns the original use of a new heat-treated, high-carbon steel wire, which later proved defective. Four months before the scheduled completion, the bridge had to be dismantled and re-erected using different wire. This caused a delay of eight months.

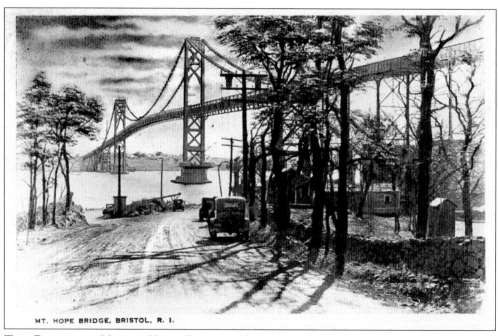

MT. HOPE BRIDGE, BRISTOL, R. I.

THE BEAUTIFUL MOUNT HOPE BRIDGE. This view is from the same vantage point as the photos on page 29. Upon completion, the structure was called the engineering wonder of the time and drew curious sightseers from miles around.

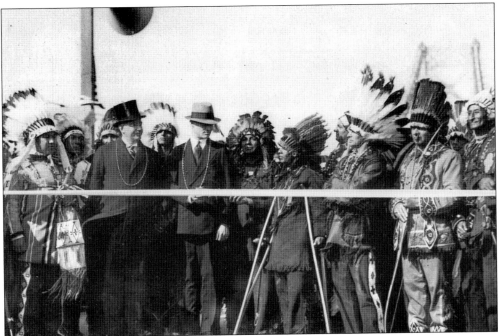

DEDICATION OF THE MOUNT HOPE BRIDGE. The opening and dedication of Mount Hope Bridge occurred on October 24, 1929, with great ceremony. Representatives of the Wampanoag and the Narragansett tribes assisted in the ribbon cutting with Rhode Island Lt. Gov. Norman S. Chase (top hat), and Sen. William H. Vanderbilt.

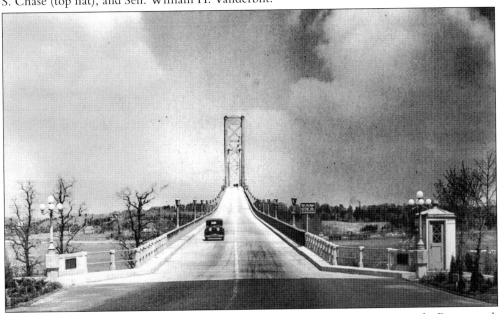

LIGHT TRAFFIC ON THE MOUNT HOPE BRIDGE. A solitary motorist crosses to the Portsmouth side. Five days after the opening of the new span, the stock market crashed. The ensuing depression and low toll revenues led to the default of the privately held bridge company in 1931. At a public auction in 1932, a new company, the Mount Hope Bridge Corporation, led by Rudolf H. Haffenreffer, purchased the bridge.

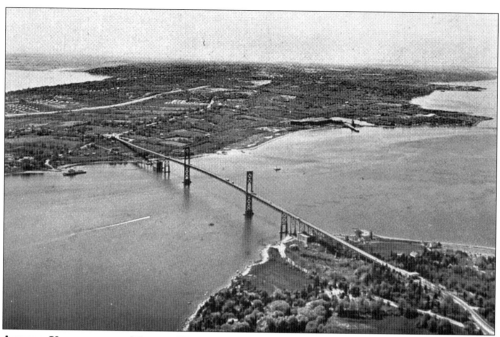

AERIAL VIEW OF THE MOUNT HOPE BRIDGE. Here is a birds-eye view of the span across Mount Hope Bay, *c.* 1965. Ferry Road can be seen clearly as it runs alongside the bridge approach and under the bridge to the lighthouse.

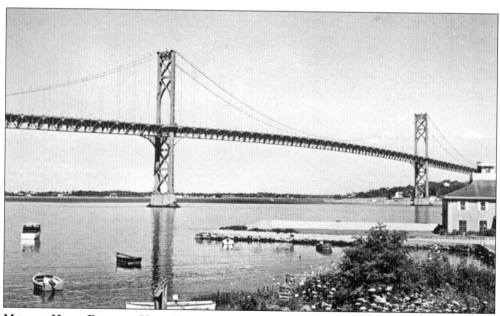

MOUNT HOPE BRIDGE, VIEW EAST TO COMMON FENCE POINT. Here the bridge is seen from the Portsmouth ferry landing, *c.* 1960. The old ferry station is at the right.

MOUNT HOPE BRIDGE, VIEW ACROSS BRISTOL FERRY. The Mount Hope Bridge is beautiful from any angle. This is a view from the east, above the Portsmouth shore around 1970.

ROGER WILLIAMS UNIVERSITY. The Bristol campus of Roger Williams University, on the former Ferrycliffe Farm, rambles down along Ferry Road to the shore adjacent to the bridge.

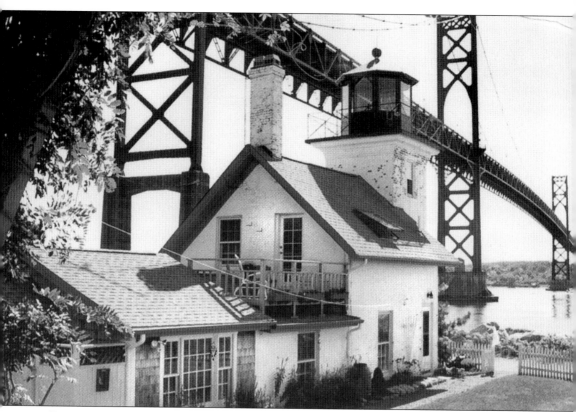

BRISTOL FERRY LIGHTHOUSE AND THE MOUNT HOPE BRIDGE, 1997. Bristol Ferry Light (1855) is now a private residence. The Mount Hope Bridge (1929) was built as a commercial toll bridge; it replaced the ferry that had been established in 1636. The span was purchased by the State of Rhode Island on November 3, 1936. Beginning on April 2, 1998, toll-free crossing of the bridge became a reality. The bulk of the toll money went to pay the toll collectors, not to the maintenance of the facility, according to Director of the State Department of Transportation William D. Ankner, so the toll collector's jobs were eliminated.

Three

THE DUSTY DIRT ROADS
OF BRISTOL

1880–1917

THE BYFIELD SCHOOL. The Byfield School now occupies the footprint of the old Methodist meeting house that was moved from the southwest corner of the town common in 1871. Cost to build the Byfield School was $40,000; its furnishings cost $4,700. The new school building was dedicated with appropriate exercises on Saturday, September 6, 1873. This photo is from around 1880.

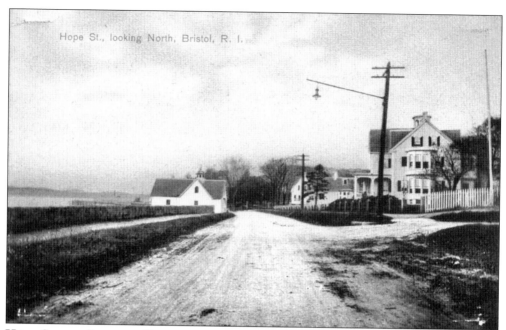

HOPE STREET LOOKING NORTH FROM THE CORNER OF BURTON STREET, C. 1909. This view shows the sea wall, old town beach, and Bristol Harbor.

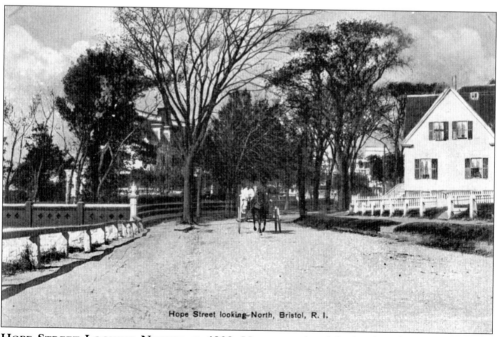

HOPE STREET LOOKING NORTH, C. 1909. Unseen to the right (east) is the home of Capt. James Lawless; to the left is the wall of the Wilbour-DeWolf House.

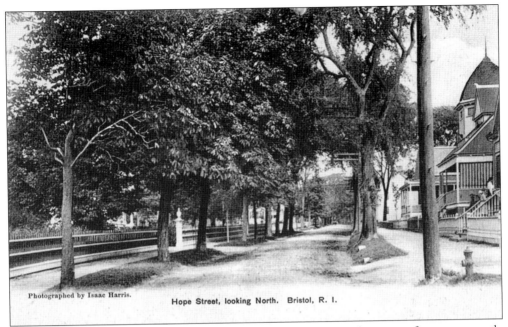

Hope Street, looking North. Bristol, R. I.

HOPE STREET LOOKING NORTH, C. 1910. Bristol's extensive urban street forest was greatly destroyed by the hurricane of September 21, 1938.

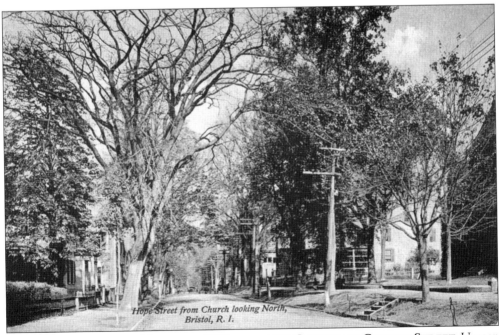

*Hope Street from Church looking North,
Bristol, R. I.*

HOPE STREET LOOKING NORTH, C. 1909, FROM THE CORNER OF CHURCH STREET. Unseen on the left is St. Michael's Episcopal Church; on the extreme right (east) is St. Michael's Chapel.

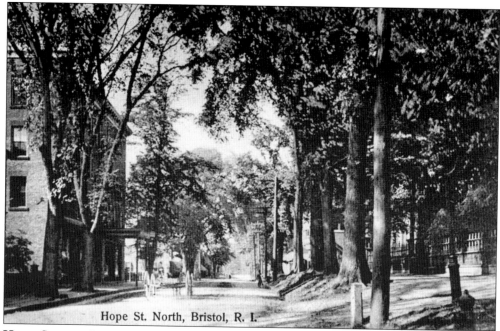

Hope St. North, Bristol, R. I.

HOPE STREET LOOKING NORTH, C. 1909. On the left is the four-story, brick Belvedere Hotel, pictured *c.* 1901. John Brown Herreshoff, president of the Herreshoff Manufacturing Company built this four-story, nearly square, 100-room brick hotel to accommodate customers while they were waiting for the delivery of their sailing or motor vessels.

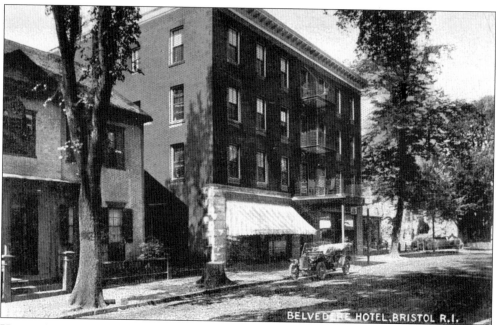

BELVEDERE HOTEL, BRISTOL R.I.

HOTEL BELVEDERE-HARRIET BRADFORD HOTEL AND THE JOHN W. BOURN HOUSE. To the south of the hotel is the John W. Bourn House, around 1804. Bourn, a wealthy shipmaster who owned 42 vessels, built this fine brick two-story, five-bay Federal house with end chimneys. In the late 1970s, sandblasting caused severe damage to the surface of the brick.

Post Card

Hotel Belvedere

BRISTOL, R. I.

A. W. HATHAWAY, Mgr.

American and European

$2.50 to 4.00 day. $1.00 to 2.50 day.

Breakfast 50. Lunch 50. Dinner 75.

Special Sunday Dinner $1.00

BROILED LIVE LOBSTERS

BROILED AND PLANKED STEAKS

AND CHICKEN A SPECIALTY.

Station 2 R. I. Auto Club

BAND CONCERT ON BALCONY

Aug. 14, 22, 29, - 8 to 10 P. M.

HOTEL BELVEDERE MENU. Special Sunday dinners were offered for $1. Guests, other than the sailing fraternity, were welcome at a daily room rate of $2.50 to $4—depending on the elegance of the accommodations.

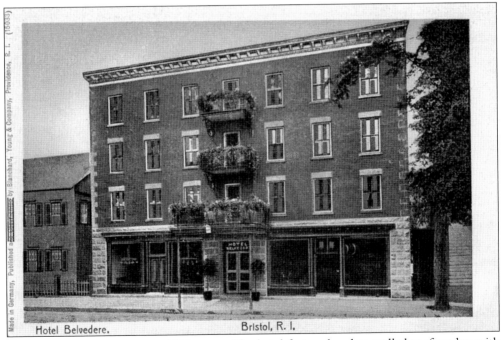

Made in Germany, Published by Blanchard, Young & Company, Providence, R. I. (15033)

Hotel Belvedere. Bristol, R. I.

HOTEL BELVEDERE IN A C. 1912 VIEW. The hotel featured a glass-walled roof garden with a pyramidal roof overlooking Bristol Harbor. Many elegant parties and dances were held here during the Roaring Twenties.

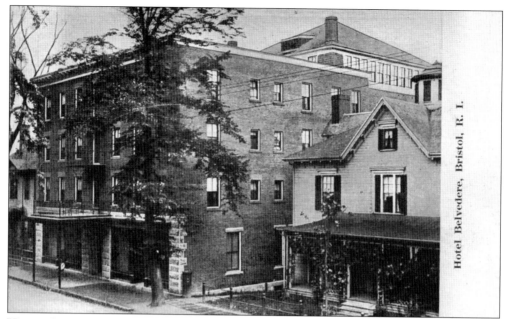

HOTEL BELVEDERE DURING ITS PRIME, C. 1917. In this view, the hotel's enclosed rooftop dining and dancing pavilion can be seen (upper right). The current street-level façade of the house on the right has been changed to two modern, two-bay entrance commercial units.

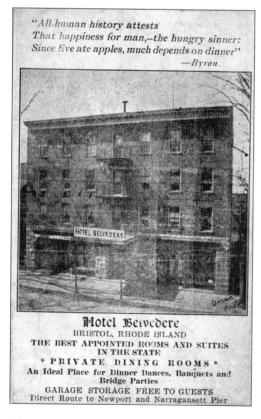

*"All human history attests
That happiness for man,--the hungry sinner:
Since Eve ate apples, much depends on dinner"*
—*Byron.*

Hotel Belvedere
BRISTOL, RHODE ISLAND
THE BEST APPOINTED ROOMS AND SUITES
IN THE STATE
* PRIVATE DINING ROOMS *
An Ideal Place for Dinner Dances, Banquets and
Bridge Parties
GARAGE STORAGE FREE TO GUESTS
Direct Route to Newport and Narragansett Pier

ADVERTISING CARD. A Hotel Belvedere Advertising Card publicizing the new "bituminous-macadam" road between Providence and Bristol.

42

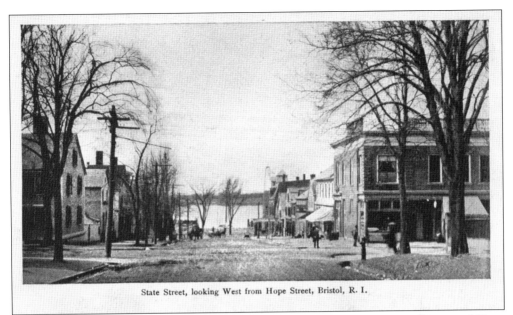

State Street, looking West from Hope Street, Bristol, R. I.

LOOKING WEST. This view looks west to Bristol Harbor at the intersection of State and Hope Streets around 1905. Except for the dirt streets, little has changed at this busy, central location over the past century.

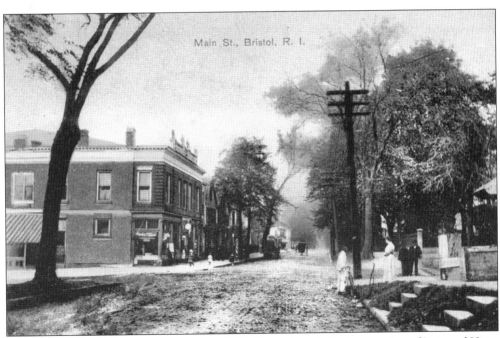

Main St., Bristol, R. I.

LOOKING NORTH ON HOPE STREET, C. 1909. Shown here is the intersection of State and Hope Streets. This is the bustling business center of town. Interestingly, this block is called "Loafer's Corner" by the locals because of the number of senior gentlemen who met contemporaries to discuss the important subjects of the day.

43

HOPE STREET, LOOKING NORTH FROM STATE STREET, BRISTOL R. I.

INTERSECTION OF HOPE AND STATE STREETS AND LOAFER'S CORNER. On the left, is the Esterbrooks-Paull Block, a handsome, two-story, five-bay, flat-roof commercial building constructed of brick in 1899. The original, cast-iron columned storefront survives on street level. The building has been recently restored to its late-19th century splendor. Unfortunately ,the delicate comb-style balustrade roof ornament is no longer in place.

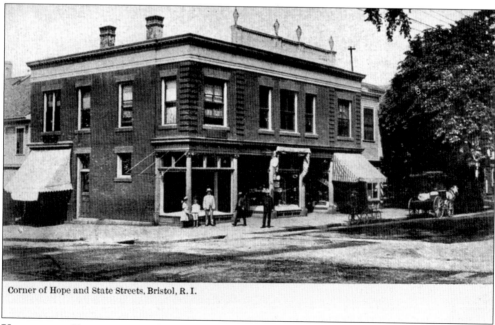

Corner of Hope and State Streets, Bristol, R. I.

VIEW OF THE ESTERBROOKS-PAULL BLOCK. Here is an excellent view of the building's Victorian-comb roof rail. Street traffic consists of horse drawn carts, wagons, and coaches. The town fathers provided boardwalks at intersections as pedestrian walkways over the muddy streets.

44

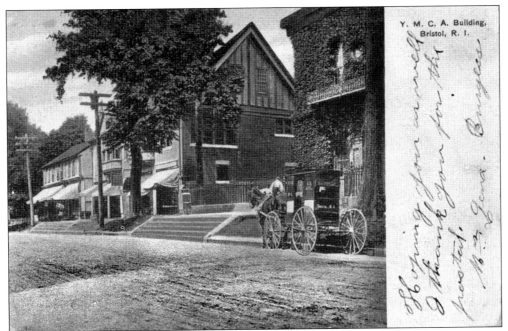

HOPE STREET FACING NORTHEAST. On the far left is the intersection of State Street, around 1907. On the corner is the Sparks dry goods store (where the Citizen's Bank is now located). The next building to the south is the Tudor-style YMCA block with its commercial stores on the ground floor. In the right foreground is the customs house and post office.

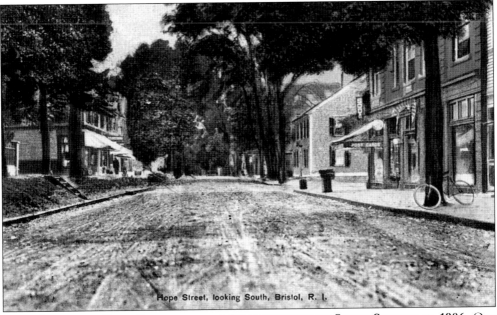

VIEW SOUTH ON HOPE STREET AT THE INTERSECTION OF STATE STREET, C. 1906. One cannot help but notice the well-forested streetscape with an abundance of towering elm. The Sparks Block is on the left; the two-story, five-bay Federal residence on the southwest corner of State Street is no longer in existence. The John DeWolf house was moved to this lot in 1915, as seen on page 55.

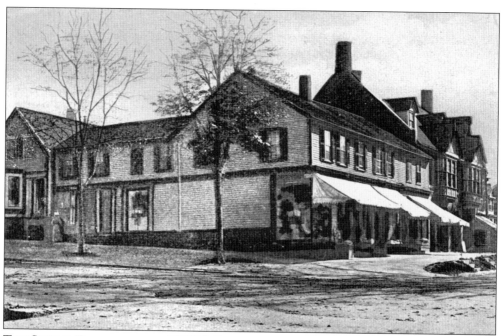

THE SPARKS BLOCK AND THE YMCA BLOCK, C. 1910. The rutted dirt intersection of Hope and State Streets is evidence of the volume of traffic at this busy central intersection.

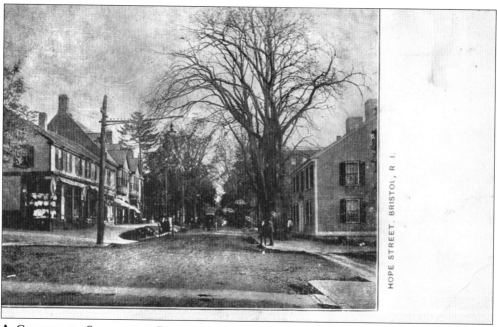

HOPE STREET, BRISTOL, R.I.

A CHANGE OF SEASONS AT LOAFER'S CORNER. In this March 1906 photo we are afforded a better view of the John DeWolf house on the southwest corner, and the pedestrian board walk.

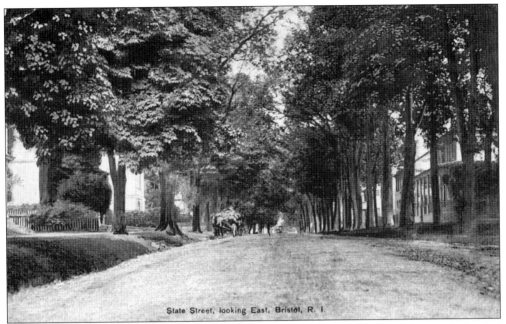

STATE STREET, LOOKING EAST FROM HOPE STREET, C. 1910. On the right (south) behind the elm trees is the house that Russell Warren designed and built for himself in 1810.

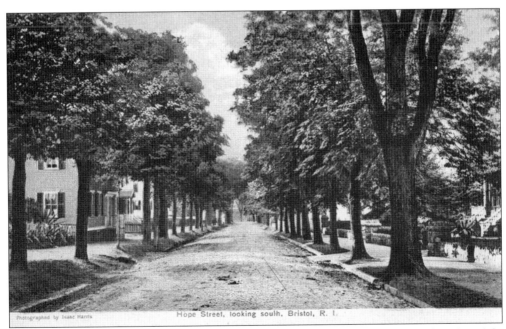

HOPE STREET, LOOKING SOUTH, C. 1910. To the right (west), is the Edward Wainwright Brunsen House (1862–1910), at number 249. The main section of this two-and-a-half-story house has a high hip roof with an elaborate cornice and balustrade. Both the house and stable in the rear have been converted to condominiums.

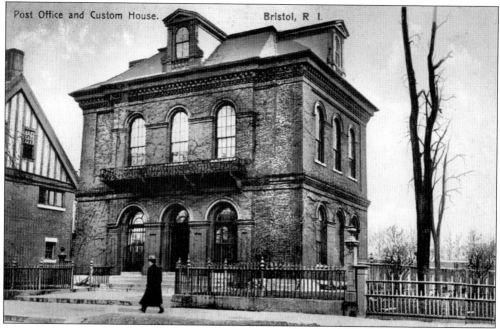

U.S. Customs House and Post Office, East Side of Hope Street, 1857. In the first decades of the 19th century, Bristol had grown very prosperous through its sea-borne commerce. Hundreds of American and foreign traders called on the port of Bristol to do business. Taking note of Bristol as an important port, steps were taken to establish a customs house.

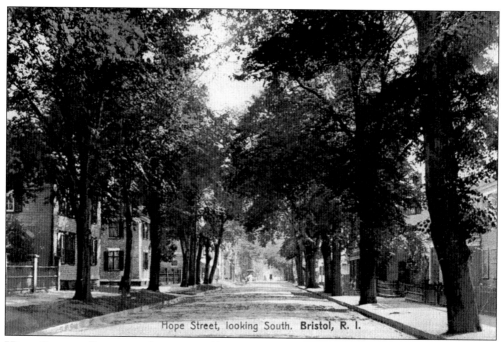

Hope Street, Looking South, c. 1910. On the right, hidden by trees, is the house with the eagles at 341 Hope Street.

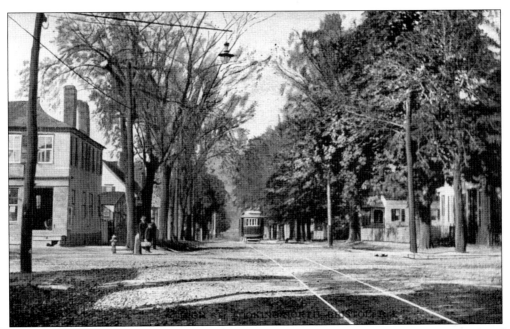

NORTH ON HIGH STREET AT THE CORNER OF BRADFORD STREET, C. 1908. The tracks of the Consolidated Rail Road ran the length of High Street. On the northwest corner is a two-story, five-bay brick townhouse with central entrance to the second floor, built around 1804. The first floor apartments have housed many commercial businesses over the years. A very fine early-20th-century structure, the building has been compromised by unsympathetic alterations.

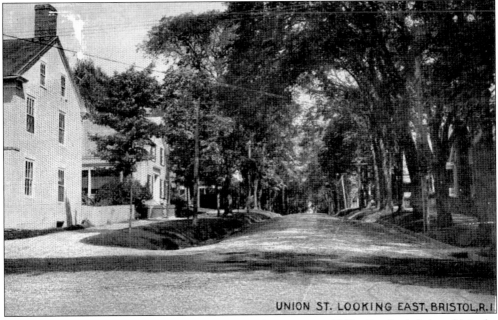

UNION STREET LOOKING EAST FROM HOPE STREET, C. 1910. On the left (north) is the Timothy French House, built in 1803. French, a carpenter-builder of many of Bristol's early 19th century dwellings built this brick house for himself. It is a small two-and-a-half-story, five-bay house with end chimneys; it is an excellent example of Federal architecture.

49

THE WEST END OF CHURCH STREET AT THAMES STREET, C. 1910. Today at this harbor-side location is the Prudence Island ferry station, Rockwell Park, and public boat dockage. At the northeast end of Church Street, at the intersection of Hope Street, is St Michael's Episcopal Church.

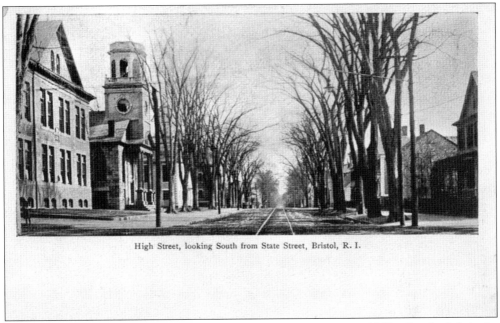

High Street, looking South from State Street, Bristol, R. I.

LOOKING SOUTH ON HIGH STREET, FROM STATE STREET, C. 1908. On the left is the Walley School, built in 1896, and the First Baptist Church, built in 1814. Except for the trolley tracks and the elm trees, this streetscape of 100 years ago looks the same in the first decade of the 21st century.

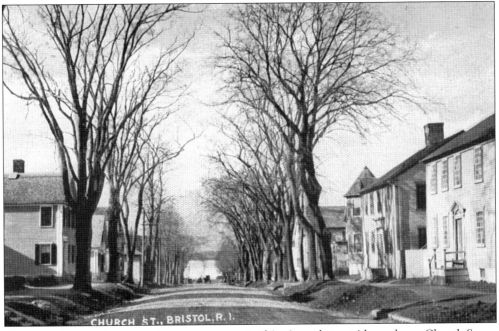

CHURCH ST., BRISTOL, R. I.

CHURCH STREET LOOKING WEST, C. 1910. In this view, about midway down Church Street from High Street, Bristol Harbor can be seen in the far background.

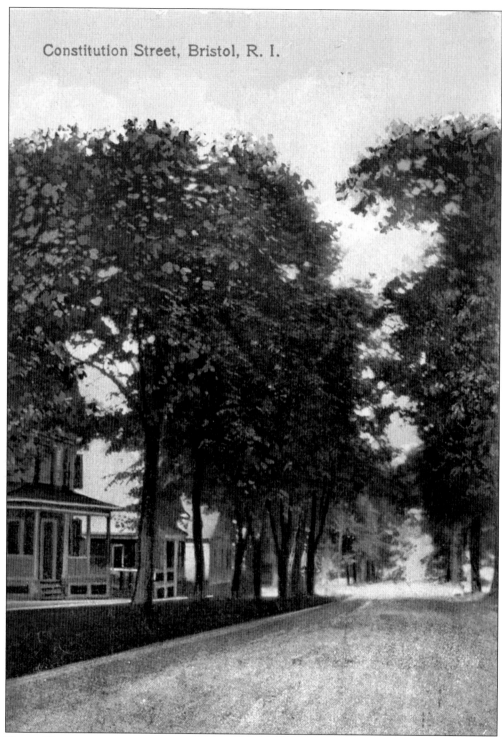

Constitution Street, Bristol, R. I.

VIEW WEST ON CONSTITUTION STREET FROM HIGH STREET, C. 1910. Continuing in evidence, at this date, are the wide dirt streets with broad grassy shoulders and the healthy rural forest of a mixed variety of trees.

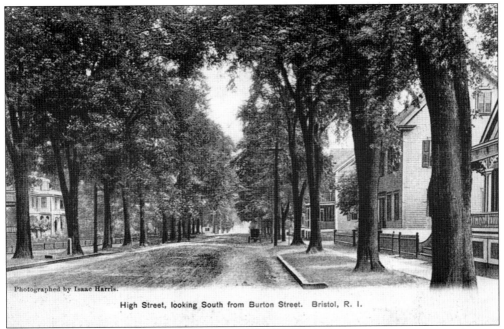

High Street, looking South from Burton Street. Bristol, R. I.

HIGH STREET LOOKING SOUTH FROM BURTON STREET, c. 1908. On the left through the trees can be seen the Codman House, built in 1870. This is a large two-and-a-half-story, three-bay, mansard-roof, Second Empire house with a three-and-a-half-story, hip roof tower on the northeast corner. In 1984, this house was converted to a multi-family dwelling.

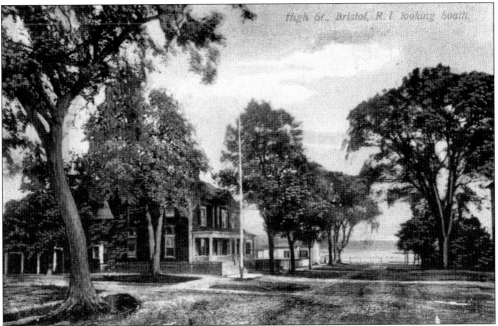

High St. Bristol, R. I. looking South.

NEAR THE WEST END OF HIGH STREET AT THE CORNER OF WALLEY STREET, c. 1910. On the left is the Jonathan Russell Bullock House, built in 1879; this is a two-and-a-half-story, three-bay, flank-gable-roof dwelling with a projecting pediment central pavilion. In the background is Bristol Harbor and Walker's Cove.

53

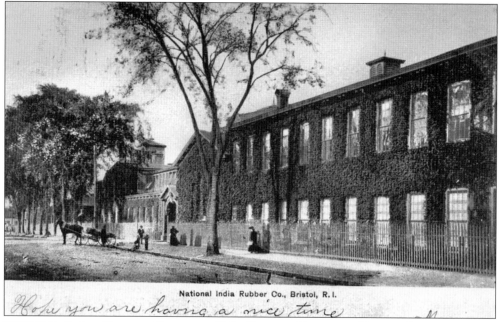

National India Rubber Co., Bristol, R.I.

Hope you are having a nice time

NATIONAL INDIA RUBBER COMPANY-U.S. RUBBER COMPANY-KAISER ALUMINUM AND CHEMICAL CORPORATION. Seen here is a large industrial complex on the east side of Wood Street. The rubber factory was the cornerstone of Bristol's economy for over three decades and was a major component of its industrial legacy. The plant closed in 1977. The sprawling array of large multi-use buildings and yards is now the Bristol Industrial Park and apartments for low-income elderly.

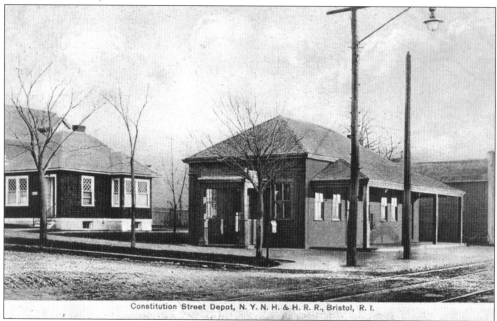

Constitution Street Depot, N. Y. N. H. & H. R. R., Bristol, R. I.

CONSTITUTION AND THAMES STREETS, C. 1912. The is the Constitution Street depot and waiting room of the Norfolk and Providence Railway and Ferry Company. This building is now an attractive private residence.

Four

The Historic Town Center

Mid-20th Century

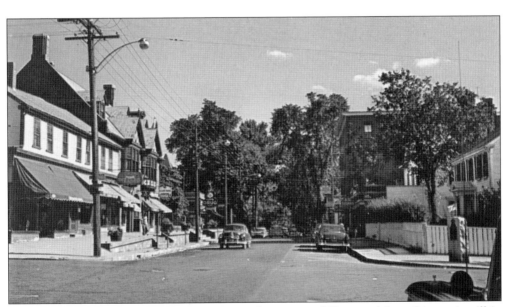

The Sparks Block. The Sparks Block, on the corner of Hope and State Streets, is still in business at this time. In the mid-1960s, when historic preservation had less importance than modernization, the Sparks Block was torn down and replaced with a pre-formed, concrete-slab bank building totally out of keeping with the town's historic streetscape. On the southwest corner is the relocated John DeWolf house, built in 1789. See photo on page 45.

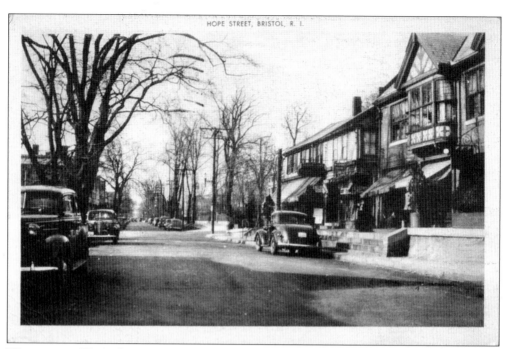

WINTER ON HOPE STREET NEAR STATE STREET. Very little has changed at this central business crossroads over the past 50 years except for the paving of Hope and State Streets, modern street lighting, and a little more vehicular traffic. In the mid-1950s, the town's population was about 12,000.

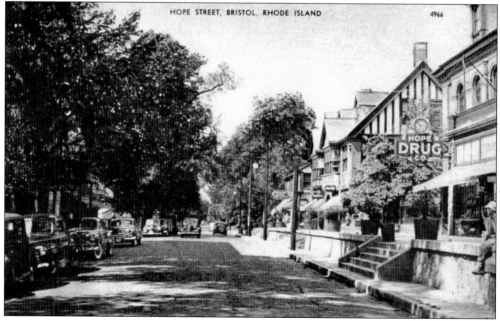

SUNNY SUMMER VIEW NORTH ON HOPE STREET NEAR STATE STREET. These two images afford the reader a nice contrast between winter and summer on Hope Street. Notice the elevated east sidewalk, unique to Bristol. This high vantage point is especially appreciated by viewers of the annual 4th of July parade.

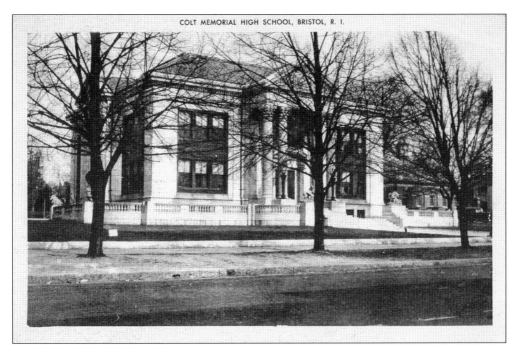

THE COLT MEMORIAL SCHOOL. In 1906, Col. Samuel Pomeroy Colt laid the cornerstone of what is the grandest public building in Bristol. Mammoth slabs of white marble are tightly fitted to form both outer and inner wall facings. The window units are bronze. The four massive Corinthian columns are each carved from a single piece of marble.

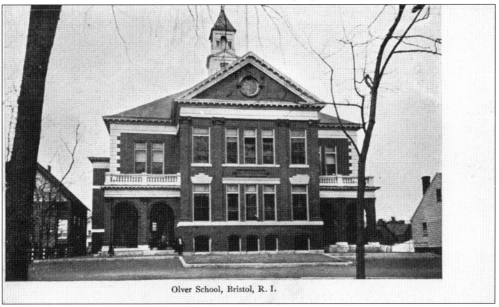

Olver School, Bristol, R. I.

THE OLIVER SCHOOL. The two-story, *c.* 1900 brick, Georgian Revival school building has a symmetrical façade. At its center is a five-bay, projecting, gable-roof pavilion flanked by two-story, hip roof wings, which contain twin arched entrances. A square steeple was removed about 1960. The building is now used as Bristol-Warren School District administration offices. For more, see *Bristol: Montaup to Poppasquash*, Arcadia Publishing, 2002, page 76.

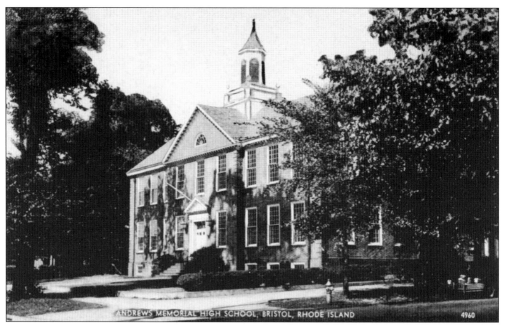

ANDREWS MEMORIAL SCHOOL. Named in memory of Robert S. Andrews, this two-and-a-half-story, T-plan, brick and brownstone Georgian Revival structure with symmetrical nine-bay façade with a pediment, projecting central pavilion has a central hexagonal cupola that crowns the cross-gable roof. It is on the northeast corner of Bradford and Hope Streets. The building is on the footprint of the former Trinity Episcopal Church and parish house.

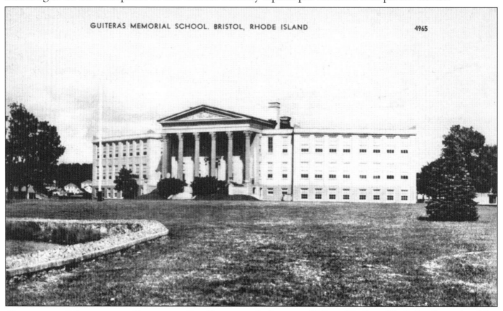

GUITERAS MEMORIAL SCHOOL. Dr. Ramon Guiteras of New York willed funds to build a school in memory of his mother. He stipulated that the structure replicate the Mudge House, built for Mark Antony DeWolf by Russell Warren in 1808, and burned in 1919, and that the building be white in color. For more on the Mudge House see *Bristol, Rhode Island*, Arcadia Publishing, 1996, page 48.

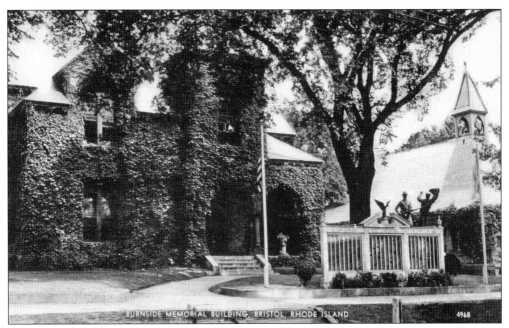

BURNSIDE MEMORIAL HALL. Stephen C. Earle of Worcester, Massachusetts, architect for Rogers Free Library, built in 1877, and St. Michael's Chapel, built in 1876, designed this elegant study of a Richardsonian Romanesque public building, built in 1883. Pres. Chester A. Arthur and Gov. Augustus O. Bourn of Bristol dedicated the building to Gen. Ambrose E. Burnside (1824–1881), whose statue was intended to be the focus of the porch.

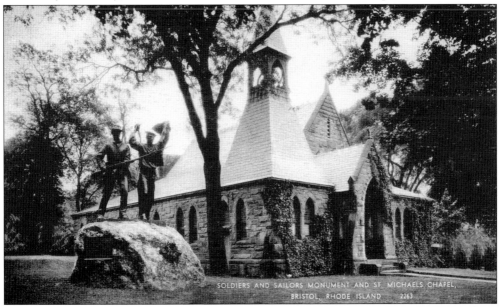

SOLDIERS AND SAILORS MONUMENT AND ST. MICHAEL'S CHAPEL. The bronze war memorial is dedicated to the soldiers and sailors of World War I. It is the guardian of the gate to the Bristol Veteran's Memorial Garden. St. Michael's parish house and chapel, built in 1876, is a Gothic Revival one-story structure with a hip-roof tower, surmounted by a steeper hip-roof belfry on the northwest corner.

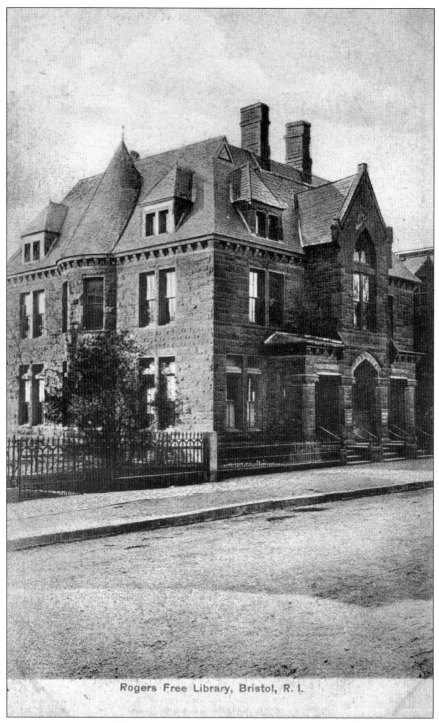

Rogers Free Library, Bristol, R. I.

ROGERS FREE LIBRARY. This photo shows the original two-and-a-half-story, Romanesque Revival building, built in 1877, with a steep hip roof, crested turrets, and hip roof dormers. After the death in 1870 of Robert Rogers, president of the Eagle Bank, his widow Maria executed his wish to build a free public library.

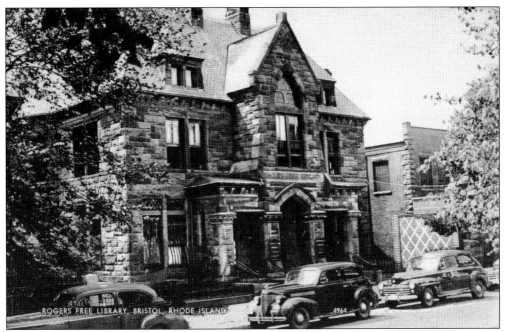

ROGERS FREE LIBRARY, C. 1950. In 1956, the upper half of the building was destroyed by fire. Bristol architect Wallis E. Howe completed a dramatic redesign, using a lower hip roof and created a one-story façade. For more on Rogers Library see *Bristol: Montaup to Poppasquash*, Arcadia Publishing, 2002, page 99.

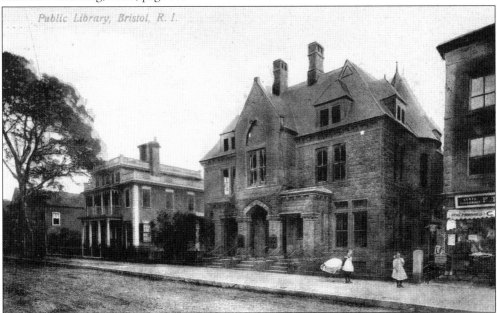

WARDWELL HOUSE, ROGERS LIBRARY, AND THE HASBROUCK BUILDING. The Bosworth-Fales-Wardwell House is a Russell Warren designed residence built in 1815. Wardwell House was razed in 1961 to make way for a new post office. The three-story Hasbrouck Building, built in 1896, was reduced to two stories after a disastrous fire on January 7, 1929. Current plans are to join Rogers Library and the Hasbrouck Building, enabling the library to expand their holdings.

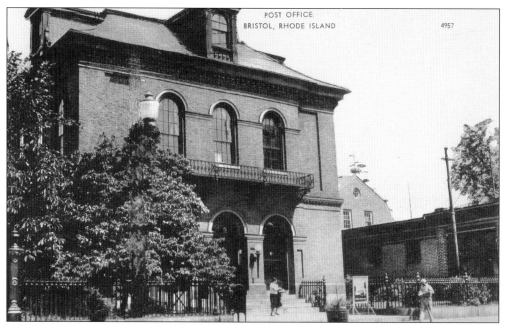

OLD POST OFFICE AND CUSTOMS HOUSE. This two-story, three-bay, Renaissance Revival public building is constructed of red brick with corbelled cornice and gray sandstone moldings and granite trim. An extensive amount of cast iron ornamentation was used; including staircases and square Corinthian columns on the first floor. In 1962 the post office moved, and in 1964, the adjacent YMCA bought the building.

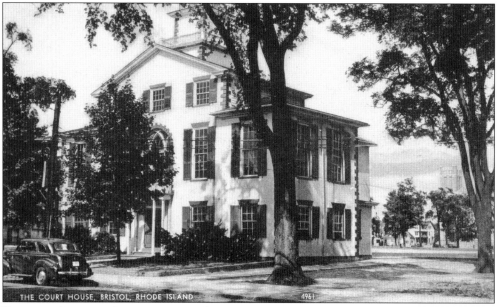

BRISTOL COUNTY COURTHOUSE. Three major buildings have been erected on this town common site. Bristol's first meetinghouse was built in 1684, and the Mount Hope Academy was built in 1791. In 1816, the town offered this site to the State of Rhode Island for a new courthouse. From 1819 to 1852, the courthouse served as one of the five state houses used in rotation by the Rhode Island general assembly.

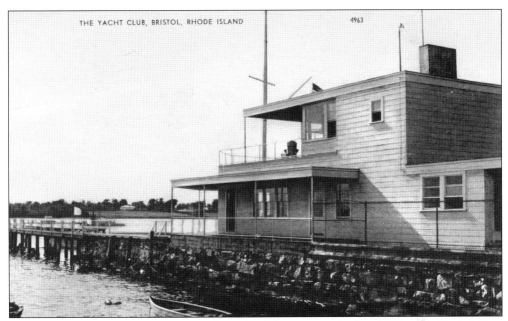

THE BRISTOL YACHT CLUB, 1940. The yacht club was organized in 1877 as the Zephyr Boat Club, in honor of the name of their single boat. The first clubhouse, built around 1900, was at the foot of Constitution Street; it was destroyed by the surprise hurricane of 1936. In its place the building pictured here was constructed. The club remained here until it moved to its new quarters on Poppasquash Road in 1955.

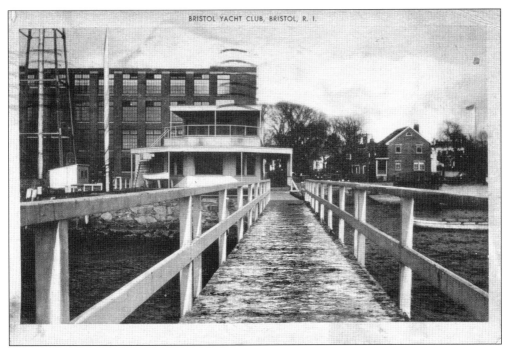

BRISTOL YACHT CLUB PIER, *C.* 1943. In the left background is the red brick manufacturing plant of the Robin Rug Division of the Bristol Yarn Corporation.

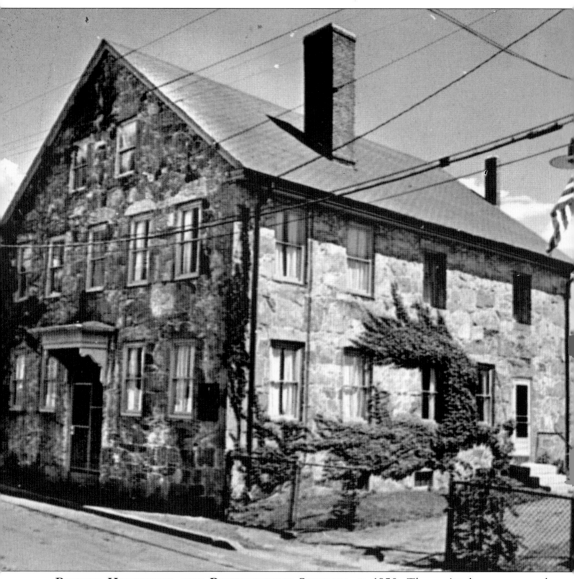

BRISTOL HISTORICAL AND PRESERVATION SOCIETY, C. 1950. The society's museum and library are housed in the old Bristol County Jail, built in 1828. This is a two-and-a-half-story, five-bay, gable roof Greek Revival structure of uncoursed ashler masonry. It was built to replace the 1792 jail on the same site. In 1859, a two-story, flat roofed, granite cell block, slightly offset to the east side was added to the original structure.

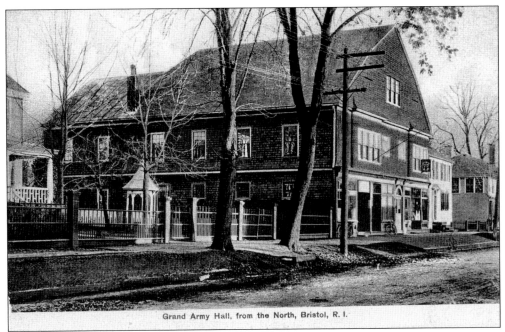

Grand Army Hall, from the North, Bristol, R. I.

GRAND ARMY OF THE REPUBLIC HALL. This hulking, *c.* 1889 Rhode Island shingle-style structure at 300 Hope Street with commercial suites on the ground level was known locally as the Bradford Block. The second floor was headquarters of Babbitt Post, No. 15, GAR, and meeting hall for the Knights of Pythias. The building was razed in December 1966; the site is now occupied by a convenience store.

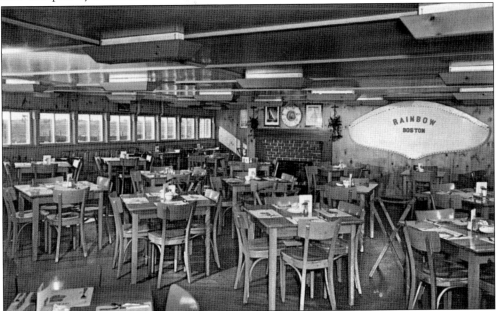

INTERIOR OF THE LOBSTER POT RESTAURANT. Since the 1930s, this was a favorite seafood dining room and watering hole for locals and tourists with sweeping views of Bristol Harbor. Before being enlarged and remolded in the early 1990s the walls were decorated with America's Cup memorabilia.

65

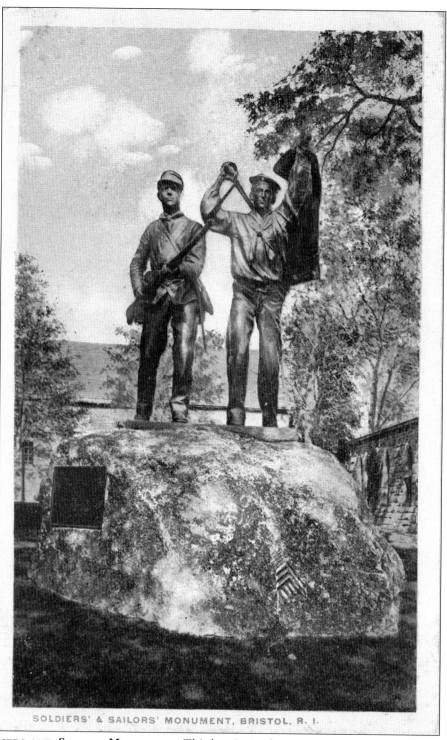

SOLDIERS' & SAILORS' MONUMENT, BRISTOL, R. I.

SOLDIERS AND SAILORS MONUMENT. This heroic size bronze monument by sculptor Henri Schönhardt, is dedicated to the veterans of the Civil War and World War I; it was erected due to the efforts of Babbitt Post No. 15, Grand Army of the Republic.

66

Five

BUSY BRISTOL HARBOR

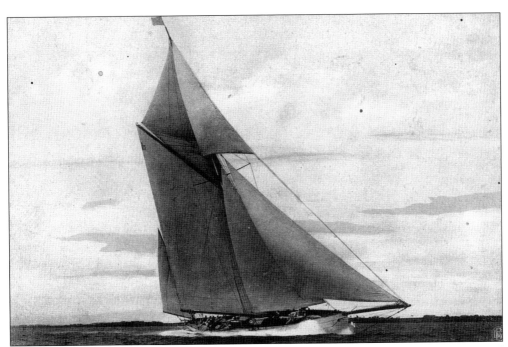

THE HERRESHOFF-BUILT AMERICA'S CUP DEFENDER THE *RELIANCE*, 1903. She was said to be the fastest boat in the world. The distance from the tip of her bowsprit to the end of her main boom was 201 feet, 9 inches. Towering 196 feet above the water, she would be unable to sail under the Mount Hope Bridge, which has a clearance of only 135 feet. See *America's Cup Yachts: The Rhode Island Connection,* Arcadia Publishing, 1999.

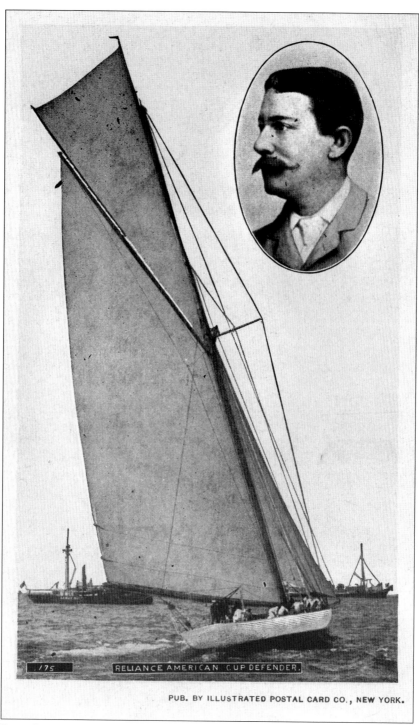

RELIANCE AMERICAN CUP DEFENDER.

PUB. BY ILLUSTRATED POSTAL CARD CO., NEW YORK.

THE WORLD'S FASTEST SAILING YACHT, 1903. The *Reliance* was extremely flat with a shallow, skimming-dish underbody, and a thin, deep keel. The durability of her steel mast was due to the engineering perfection of Capt. Nat Herreshoff. The inset portrait is of the *Reliance*'s manager, C. Oliver Iselin.

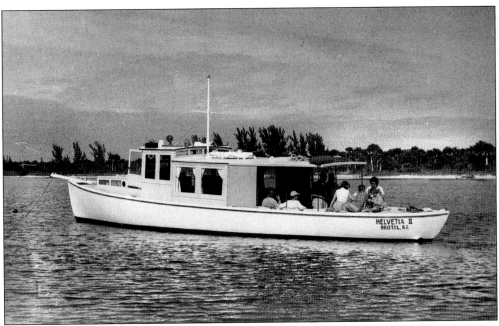

THE HERRESHOFF-BUILT LAUNCH THE *HELVETIA II*. The Herreshoff Manufacturing Company built this 49 foot 6 inch gasoline motor launch for C. Oliver Iselin in 1903. In this postcard photo, the owner and his guests are enjoying a relaxing moment off the Poppasquash shore in Bristol Harbor.

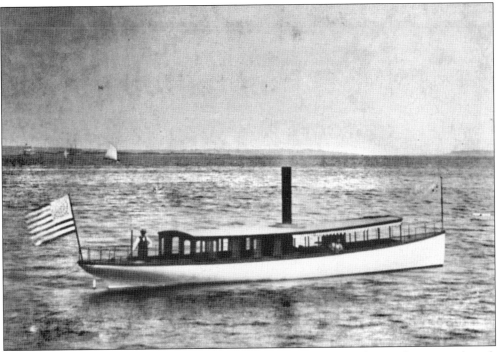

THE HERRESHOFF-BUILT STEAM LAUNCH, THE *DIDO*, 1881. This 60-foot steam launch of 9-foot beam, 4-foot, 7-inch draft is typical of the steam launches built at the Herreshoff Manufacturing Company in the last part of the 19th century.

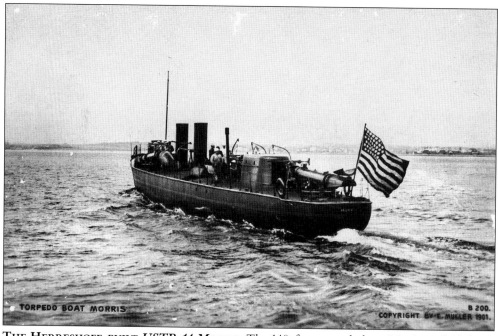

THE HERRESHOFF–BUILT *USTB-14 MORRIS*. The 140-foot torpedo boat *Morris* was laid down at the Herreshoff yard on November 19, 1897; she was launched into Bristol Harbor on April 18, 1898. Here she is seen undergoing trials in Narragansett Bay. For more on Hereshoff's torpedo boats, see *Building the Mosquito Fleet: U.S. Navy's First Torpedo Boats*, Arcadia Publishing, 2001.

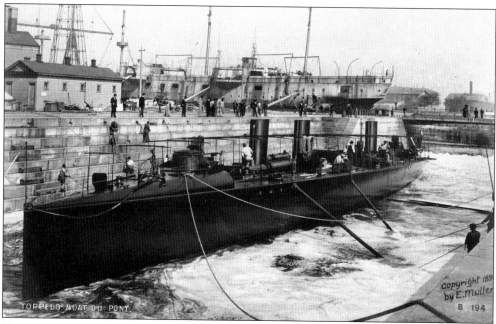

THE HERRESHOFF–BUILT *USTB-7 DUPONT*. The 175-foot torpedo boat *Dupont* was launched into Bristol Harbor, from the Herreshoff yard on March 30, 1897. In this photo she is floating free in the flooded dry-dock at the Brooklyn Navy Yard, 1898.

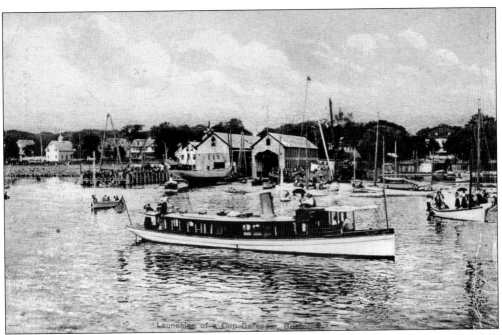

LAUNCHING A CUP DEFENDER, C. 1908. Launch day was always a cause for the town's folk to gather around the yard on the shore or on the water to celebrate.

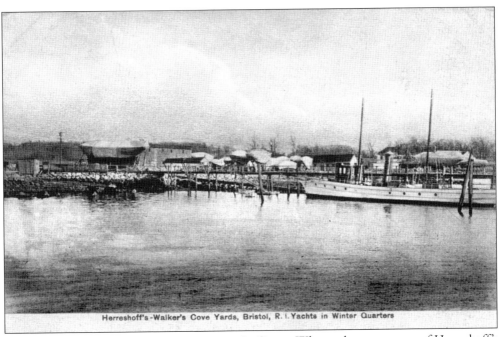

YACHTS IN WINTER STORAGE AT WALKER'S COVE. When a dozen or more of Herreshoff's sleek flyers were in their cradles and covered at the Walker's Cove winter storage facility, locals referred to the site as Peacock Alley.

HOPE STREET AT WALKER'S COVE. Seen here is early spring along the unpaved dusty southern end of Hope Street along the harbor at Walker's Cove; two Herreshoff sailors are still under their winter wraps.

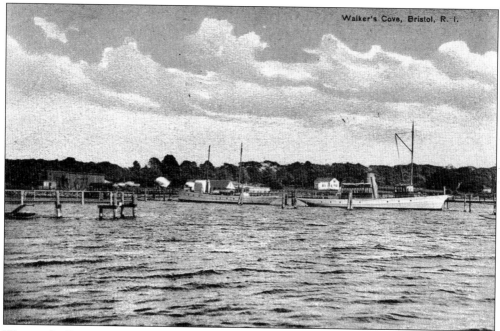

WALKER'S COVE MOORING, C. 1908. Two of Herreshoff's luxury steam yachts are moored at Walker's Cove.

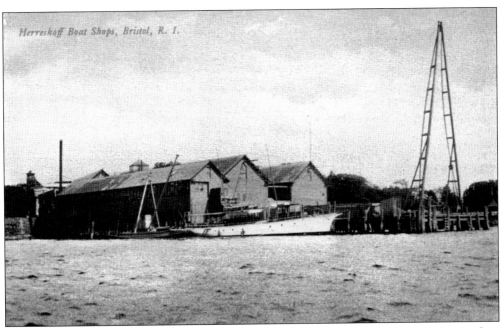

HERRESHOFF YACHT CONSTRUCTIONS SHEDS, C. 1914. Notice a third shed is now in place north of the original two (see page 71). The large metal structure reaching into the air at the end of the dock is a latticed-steel sheer leg; it is used to raise a yacht's mast into place.

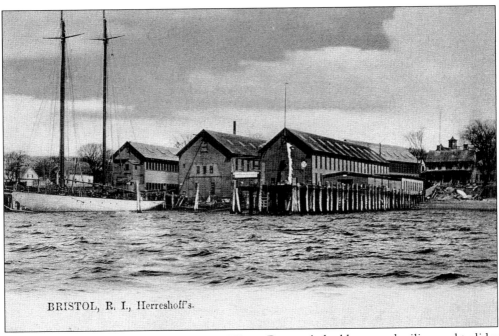

WHERE HERRESHOFF CUP DEFENDERS WERE BUILT. A double-masted sailing yacht glides next to her pier.

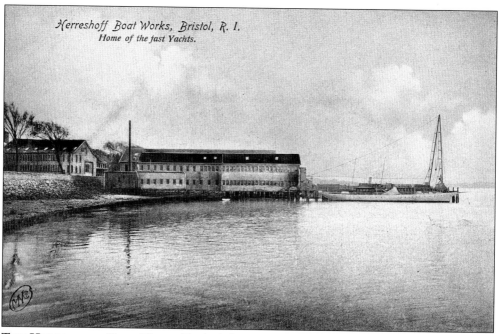

Herreshoff Boat Works, Bristol, R. I.
Home of the fast Yachts.

THE HERRESHOFF BOAT YARD. To the left (east) in this photo are the Herreshoff's east shop and mould lofts.

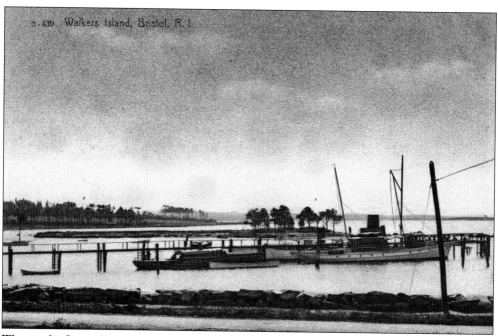

c. 430 Walkers Island, Bristol, R. I.

WALKER'S COVE DOCKAGE. South Hope Street once ran close alongside Bristol Harbor at Walker's Cove. Now from the foot of High Street to the intersection of Ferry Road, the cove has been partly filled in and lavish homes have been built.

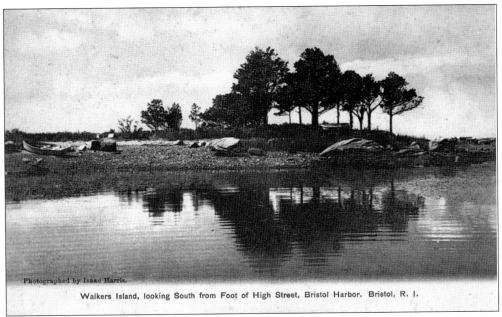

Walkers Island, looking South from Foot of High Street, Bristol Harbor. Bristol, R. I.

WALKER'S ISLAND, C. 1908. Seen here is a close-up view of Walker's Island, looking south from the foot of High Street. The hurricanes of the past hundred years have washed away all the earth and vegetation from the island, and it is now a baron landscape of boulders.

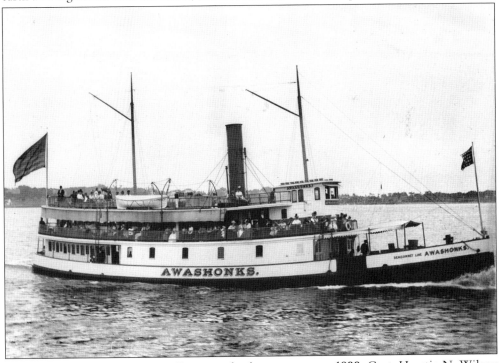

THE SEACONNET STEAMBOAT COMPANY'S *AWASHONKS, C. 1899.* Capt. Horatio N. Wilcox with Capt. Julius A. Pettey, and others organized the Seaconnet Steamboat Company, running the steam ferries the *Islander*, the *Queen City*, the *Dolphin*, and the *Awashonks* between Sakonnet Point, Bristol, and Providence with a stop at Fogland.

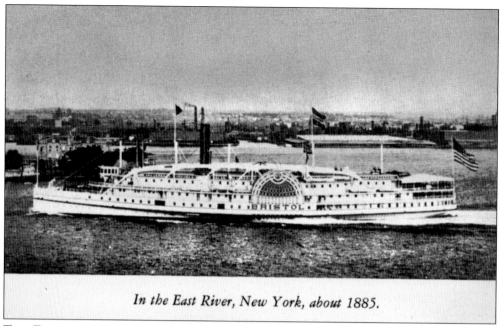

In the East River, New York, about 1885.

THE EXCURSION STEAMER *BRISTOL*. Built in 1867, the *Bristol* is the renamed *Pilgrim*. The *Bristol*, owned by the Narragansett Steamship Company, was one of the finest excursion steamers at that time; she operated for a time from Bristol to New York City, but was later transferred to the Fall River Line. The *Bristol* was destroyed by fire at Newport in 1888.

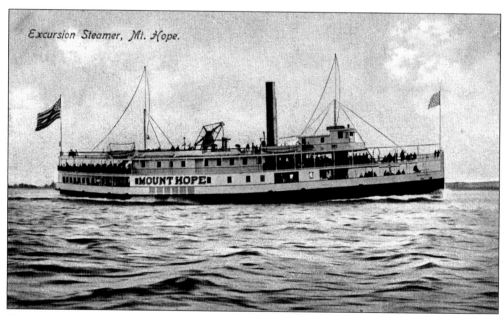

Excursion Steamer, Mt. Hope.

THE EXCURSION STEAMER *MOUNT HOPE*. The *Mount Hope*, probably the most popular steamer ever to run on Narragansett Bay connected Providence and Fall River, Sakonnet Point, Newport, Warren, and Bristol. She also made a daily run out to Block Island. Her last runs were made in 1934, after which she was scrapped in Providence. During their heydays, in the 1800s, excursion steamers carried upwards of 600,000 passengers, peaking at 1,250,000 in 1900.

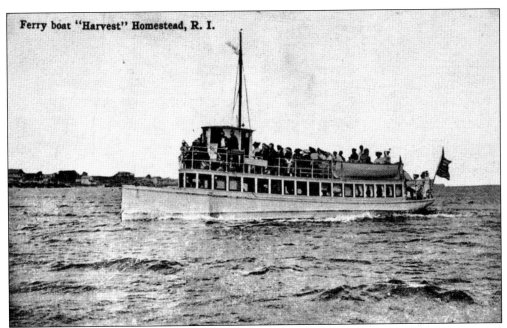

Ferry boat "Harvest" Homestead, R. I.

THE PRUDENCE ISLAND FERRY *MV HARVEST*. The ferry approaches its Homestead Dockage, around 1914. By 1876, two summer cottages were constructed on Prudence Island, at Prudence Park. By 1900, there were about 40 cottages on the island, and it had become a popular summer retreat.

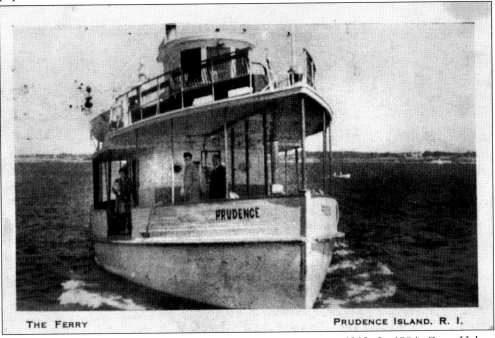

THE FERRY PRUDENCE ISLAND. R. I.

THE *MV PRUDENCE* DEPARTING ITS BRISTOL LANDING, C. 1918. In 1904, Capt. Halsey Chase began the present ferry service from Bristol to Prudence Island; a wharf was built at Sandy Point around 1909. Captain Chase made the daily summer round trips to the island from 1910 to 1929.

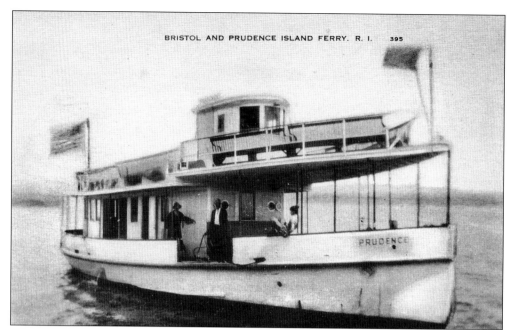

THE *MV PRUDENCE* APPROACHES BRISTOL, *C.* 1936. In 1921, the Prudence Island Navigation Company received its charter to operate the ferry. With secure dockage at both Homestead and Sandy Point, and with regularly scheduled ferry service from Bristol, the island's value as a summer retreat became increasingly important. These "summer colonies" continue to attract vacationers today.

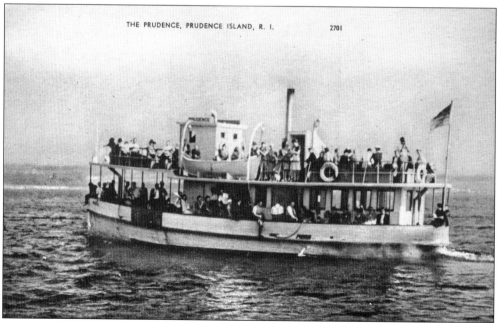

THE *MV PRUDENCE*, *C.* 1947. With the arrival of warm spring weather, the Prudence Island colonists flock to their cottages to prepare for their summer retreats.

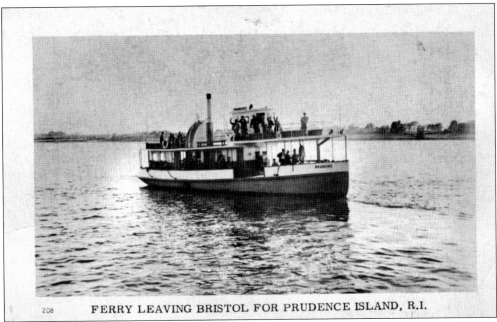

FERRY LEAVING BRISTOL FOR PRUDENCE ISLAND, R.I.

THE *MV PRUDENCE* **DEPARTING BRISTOL, C. 1951.** For nearly 20 years the original *MV Prudence*, operated by the Prudence Island Navigation Company, made two round trips daily without a mishap.

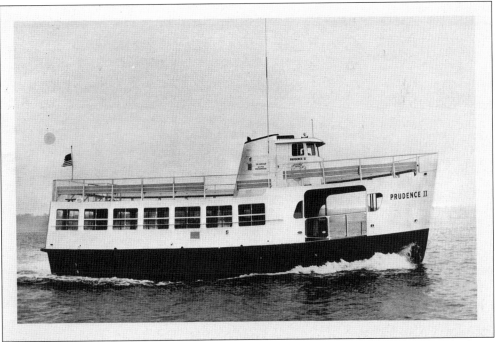

THE *MV PRUDENCE, C.* **1962.** Today the Prudence Island Ferry operates two wide-beam, double-ender ferries capable of transporting several vehicles and many passengers to Prudence and Hog Islands from its Church Street wharf.

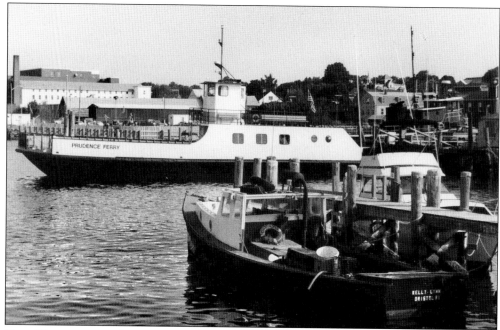

THE VEHICLE AND PASSENGER FERRY *PRUDENCE* AT ITS CHURCH STREET LANDING, SEPTEMBER 1995. The white stone Premier Thread plant is in the left background. Stone Harbour Condominiums and Thames Street Landing developments have not begun at this time.

THE FERRY *RIVERLINK*, AUGUST 2004. The newly purchased passenger ferry *Riverlink* will be pressed into service on the Bristol to Prudence and Hog Islands, run by the Prudence Island Navigation Company.

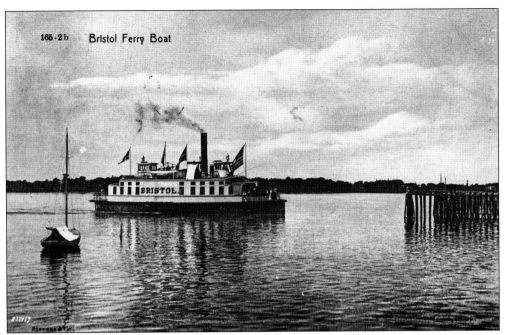

165-2b Bristol Ferry Boat

BRISTOL

THE *BRISTOL* ENTERS HER CONSTITUTION STREET SLIP, C. 1908. Before construction of the Mount Hope Bridge, the only connection to the Portsmouth trolley for the journey to Newport or Fall River was passage aboard the *Bristol*.

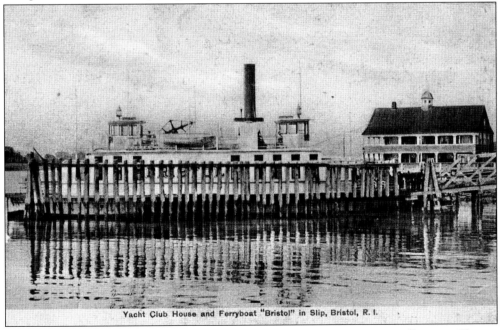

Yacht Club House and Ferryboat "Bristol" in Slip, Bristol, R. I.

THE *BRISTOL* AT HER CONSTITUTION STREET SLIP, ADJACENT TO THE BRISTOL YACHT CLUB, C. 1910. From about 1900 until the opening of the Mount Hope Bridge in 1929, electric trains traveled the length of Thames Street to Constitution Street, where the Coast Guard's Aid to Navigation Station is now located. From this point, travelers boarded the ferry to Portsmouth.

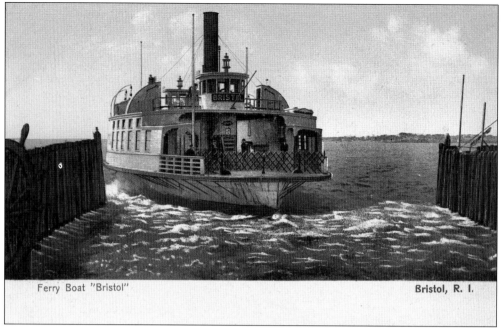

Ferry Boat "Bristol" Bristol, R. I.

THE *BRISTOL* DEPARTS HER SLIP FOR PORTSMOUTH. The Newport and Providence Railway Company placed the steamer *Sagamore* on the line and the company built new slips on Thames Street, at the foot of Constitution Street and at the Bristol Ferry landing on the Portsmouth side. The ferry left Bristol Harbor to Portsmouth, docking at the ferry station. See page 30.

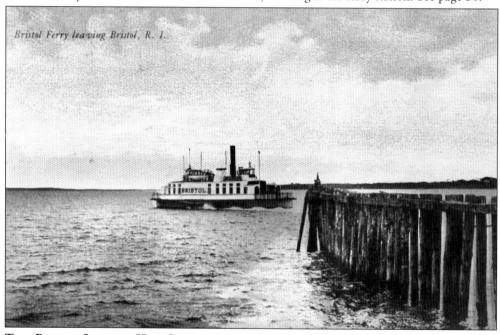

Bristol Ferry leaving Bristol, R. I.

THE *BRISTOL* LEAVING HER CONSTITUTION STREET SLIP. The ferry link between Bristol and Portsmouth formed a continuous transportation link for the New York, New Haven, and Hartford Railroad where trains could be boarded for Providence and points beyond, and passengers could ride the electric trolley to Newport, Island Park, and Fall River.

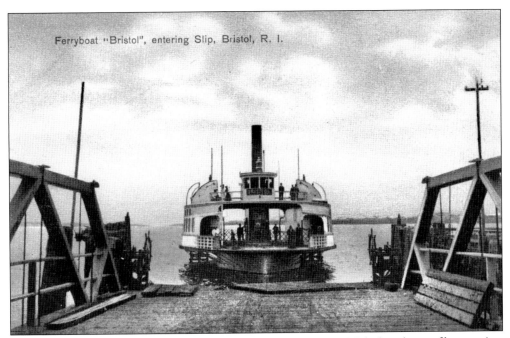

THE *BRISTOL* ENTERING HER CONSTITUTION STREET SLIP. With the advent of bus service, the Bristol terminus for the Newport and Providence Street Railway Company (trolley line), which owned steamer *Bristol*, relocated to its original site at the end of Ferry Road.

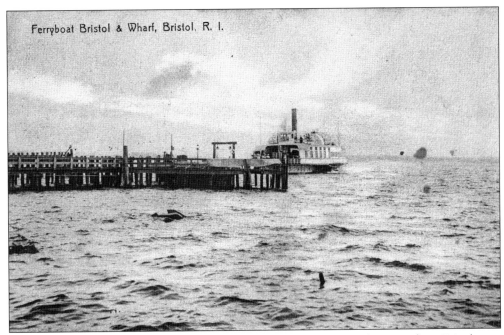

A VIEW OF THE *BRISTOL* ENTERING HER BRISTOL FERRY SLIP. The steam ferry *Bristol* came into service in 1905. She was a double-ender and primarily a summer boat run to accommodate bus, truck, and wagon traffic.

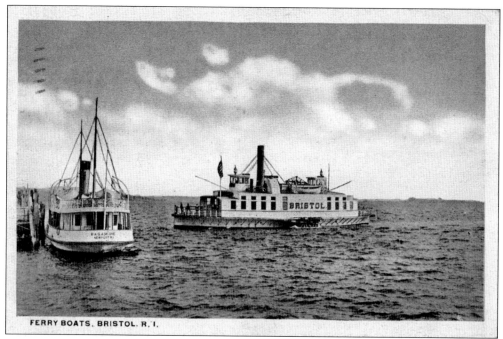

FERRY BOATS, BRISTOL, R. I.

THE *BRISTOL* APPROACHES HER SLIP WHILE THE *SAGAMORE* FROM NEWPORT STANDS BY, *C.* 1915. The *Bristol* and the *Sagamore* were the workhorses of the Newport and Providence Street Railway Company. When the Mount Hope Bridge opened to traffic in October 1929, the ferries became redundant and the commuter line was discontinued.

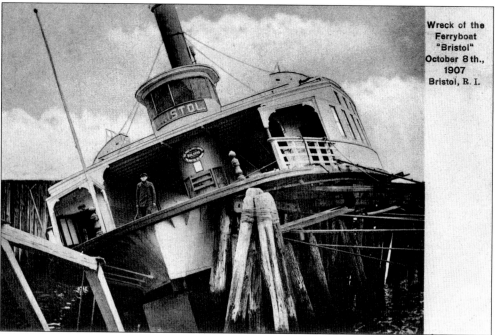

Wreck of the Ferryboat "Bristol" October 8th., 1907 Bristol, R. I.

WRECK OF THE STEAMER FERRY *BRISTOL* AT HER CONSTITUTION STREET LANDING, OCTOBER 8, 1907. Evidently, the damage sustained by the *Bristol* was superficial because there is evidence that she continued her regularly scheduled Bristol to Portsmouth run until October 1929.

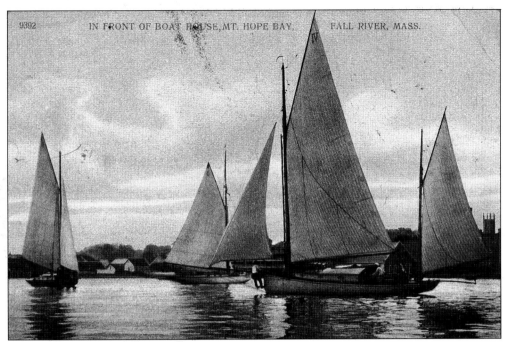

9392 IN FRONT OF BOAT HOUSE, MT. HOPE BAY, FALL RIVER, MASS.

DAY SAILORS IN BRISTOL HARBOR, *C.* 1908. The publisher of this postcard misjudged this image to be of Fall River; the tower of St. Michael's Church in the extreme right reveals the true location.

The Head of Bristol Bay, Bristol, R. I.

THE SEAWALL, EAST BRISTOL HARBOR, *C.* 1910. This tranquil scene with small boats appears to be located off-shore of the old railroad depot where Independence Park is now located. Windmill Point is at the upper right. At the bend of the harbor where the Castle Restaurant was located, the Windmill Point Condominium complex now occupies the site.

BRISTOL HARBOR AND WALKER'S COVE AS SEEN FROM THE FOOT OF HIGH STREET, *C.* **1915.** In the near background are the shoal of rocks that form the foundation of Walker's Island. The long spit of land in the far background is the McKee property.

Made in Germany. Published exclusively by Blanchard, Young & Company, Providence, R. I. (16035)

Bristol Water front. Bristol, R. I.

VIEW OF BRISTOL HARBOR'S EAST SHORE AS SEEN FROM THE POPPASQUASH SHORE, *C.* **1920.** From left to right in this view are a cluster of waterfront warehouses, the spire of the State Street Methodist Church, the DeWolf Inn, Prudence Island ferry slip, the U.S. Volunteer Life Saving Station, the steeple of St. Michael's Church, and the U.S. Naval Reserve Armory.

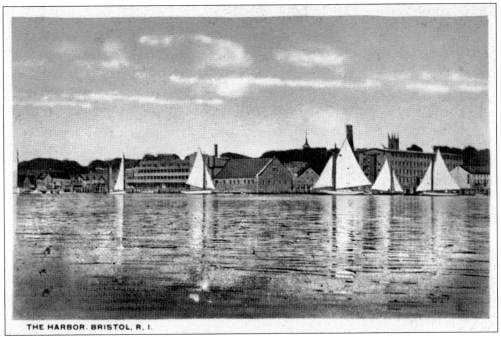

THE HARBOR. BRISTOL, R. I.

A Northeast View of Bristol Harbor's East Shore, c. 1920. A slight shift in the camera angle allows us an end view of the U.S. Naval Reserve Armory, and on the right we can see the Robin Rug factory, and the Yacht Club building.

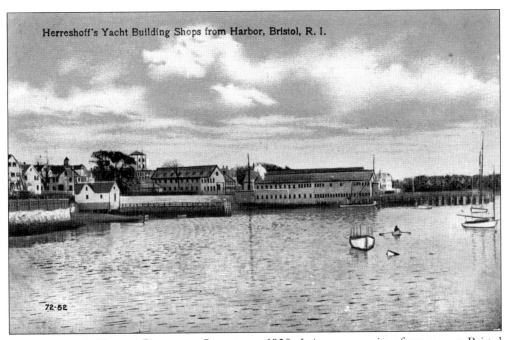

Herreshoff's Yacht Building Shops from Harbor, Bristol, R. I.

72-52

Herreshoff's Yacht Building Shops, c. 1920. It is a rare, quiet afternoon on Bristol Harbor. The seawall of the Wilbour-DeWolf House is seen on the extreme left.

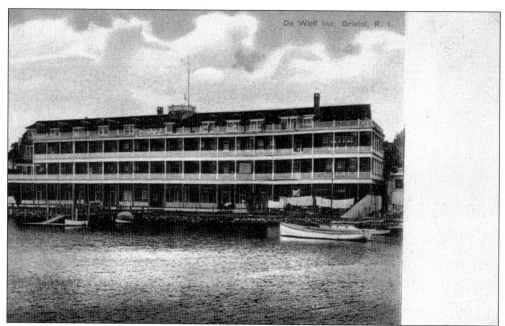

THE DEWOLF INN, C. 1920. The four-story gambrel roofed structure with its many rooms with sheltered porches facing Bristol Harbor was a popular vacation destination for heat-oppressed city dwellers. This site is now the popular Rockwell Park and public small boat slips

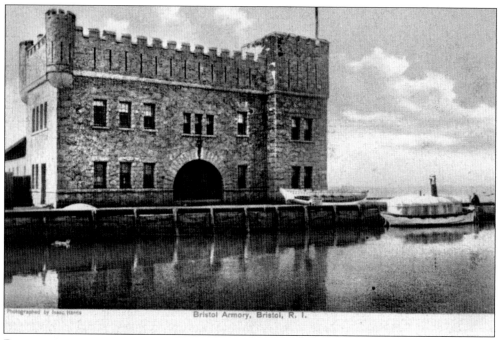

BRISTOL NAVAL RESERVE TORPEDO COMPANY ARMORY. In 1891, this Romanesque Revival armory was built on Long Wharf. After the new armory was built on Metacom Avenue, the town purchased this building for use as a community center.

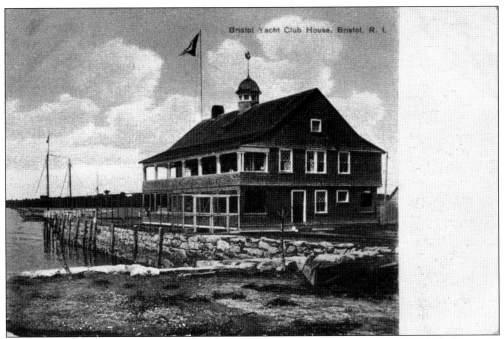

BRISTOL YACHT CLUB HOUSE, *c.* **1900.** Organized in 1877, the monthly dues were 5¢ and there was no initiation fee. Anyone being in arrears for six months and thereby owing the large sum of 30¢ was liable to expulsion.

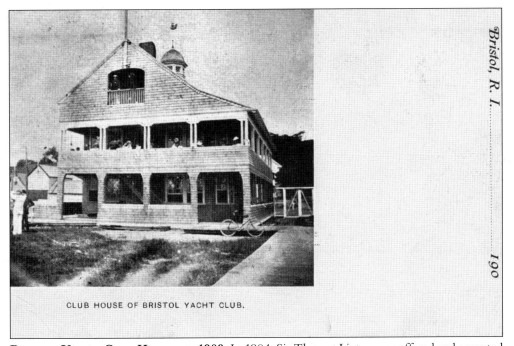

CLUB HOUSE OF BRISTOL YACHT CLUB.

Bristol, R. I. *190*

BRISTOL YACHT CLUB HOUSE, *c.* **1909.** In 1904, Sir Thomas Lipton was offered and accepted an invitation to become an honorary member of the club.

A VIEW OF BUSY BRISTOL HARBOR FROM THE POPPASQUASH SHORE OF THE BRISTOL YACHT CLUB, 1999. The annual commissioning ceremonies held on May 6, 2001, were especially auspicious because it was the day of the acceptance of the club building's completed $400,000 addition and renovation.

AMERICA'S CUP DEFENDER *AMERICA*3, 1992. Built in Bristol by the Goetz Custom Sailboats Company for Bill Koch, the yacht is on permanent display at the Herreshoff Marine Museum, at the Hope and Burnside Street site of the original Herreshoff Manufacturing Company.

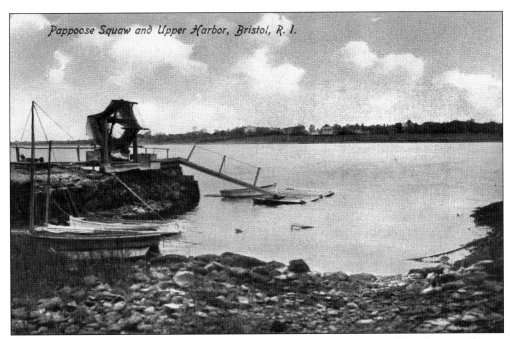

Pappoose Squaw and Upper Harbor, Bristol, R. I.

FISHING NETS DRYING ON BRISTOL HARBOR SHORE, C. **1905.** This photograph was taken from the current fisherman's boat launching area next to Independence Park. In the far background, on the Poppasquash shore, is the Mudge-DeWolf House.

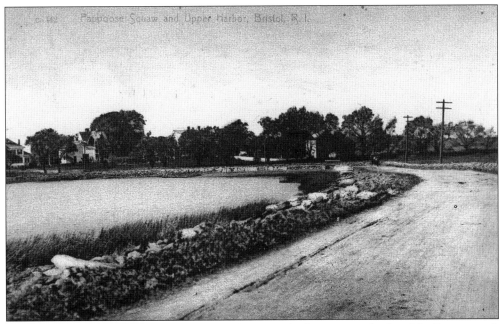

Pappoose Squaw and Upper Harbor, Bristol, R. I.

HEAD OF BRISTOL HARBOR, C. **1907.** This view looks west, at the bend in Poppasquash Road. In the far left background can be seen the Church family compound.

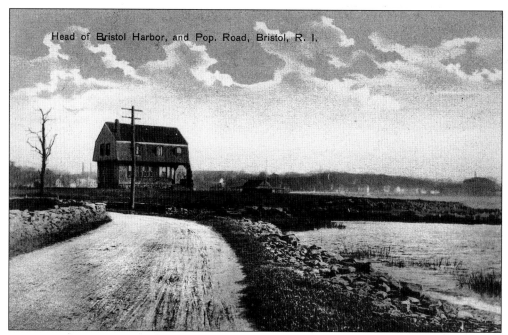

Head of Bristol Harbor, and Pop. Road, Bristol, R. I.

THE BEACH LOT AT THE HEAD OF BRISTOL HARBOR, C. 1907. This is a view of the John W. Church house, built around 1900, called Harbour Point looking east at the bend in Poppasquash Road. The building was originally a one-and-a-half-story, gambrel roof, Queen Anne summer cottage; a two-story conical tower on the west façade was added later.

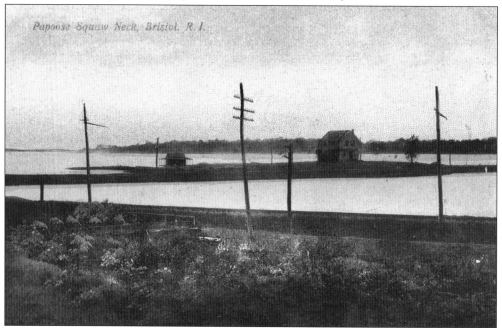

Papoose Squaw Neck, Bristol. R. I.

ANOTHER VIEW OF THE HARBOUR POINT HOUSE, C. 1910. In the background of this view is Bristol Harbor. Poppasquash Road and Harbour Point are on the narrow piece of land that borders Bristol Harbor and the tidal basin. This vantage point appears to be from the old railroad right-of-way that is now the East Bay bike path.

Six

THE CHURCHES OF BRISTOL

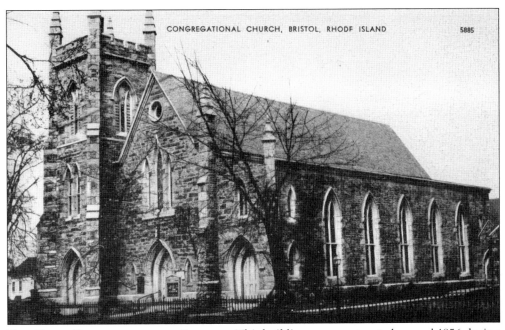

THE FIRST CONGREGATIONAL CHURCH. This building was constructed around 1856 during the pastorate of the Reverend Thomas Shepard, a leading advocate for public education in Rhode Island. Later additions include the DeWolf Memorial Chapel in 1869, and the modern church school in 1961.

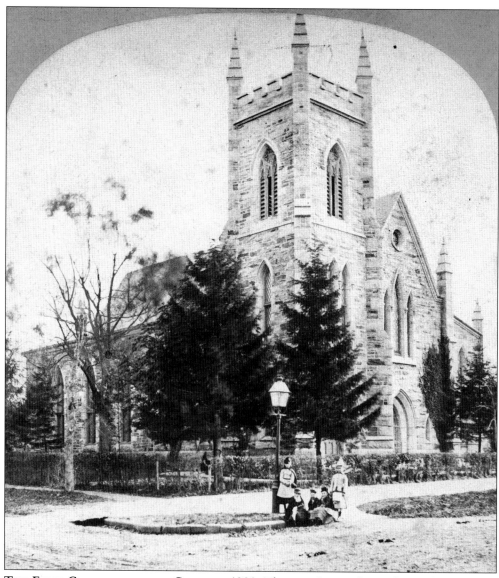

THE FIRST CONGREGATIONAL CHURCH, 1880. The proprietors of Bristol were fully imbued with the spirit of the Puritan, and took measures to secure an able gospel ministry. During the first year of habitation in the Mount Hope Lands (1680), the congregation obtained the services of the Reverend Benjamin Woodbridge. The town rented a house for the use of Woodbridge and his family. One room in the house was used for Sabbath services.

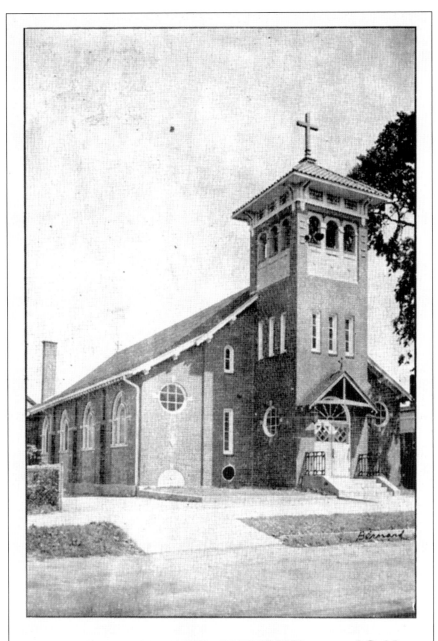

1916 - SILVER JUBILEE - 1941

Our Lady of Mount Carmel Church

BRISTOL, RHODE ISLAND

OUR LADY OF MOUNT CARMEL CATHOLIC CHURCH. This end gable roof brick and limestone church is based on Italian Renaissance models. Its distinctive campanile centered on the façade is roofed with green-glazed tiles. The church was built as a missionary outpost to service Bristol's Italian immigrants. In 1971, an open arcade was added to the façade.

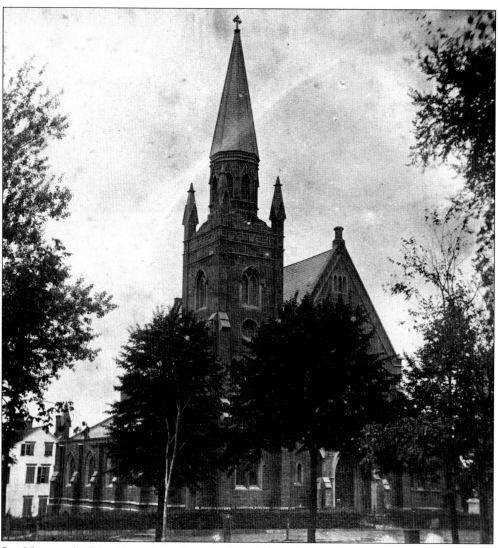

St. Michael's Episcopal Church, c. 1885. Here is an exceptional photographic image of the church's tower spire that was removed in 1891. The British burned the first church building in 1778. A plain wood meetinghouse was built in 1785, which was replaced in 1833. This third structure was destroyed by fire in 1858.

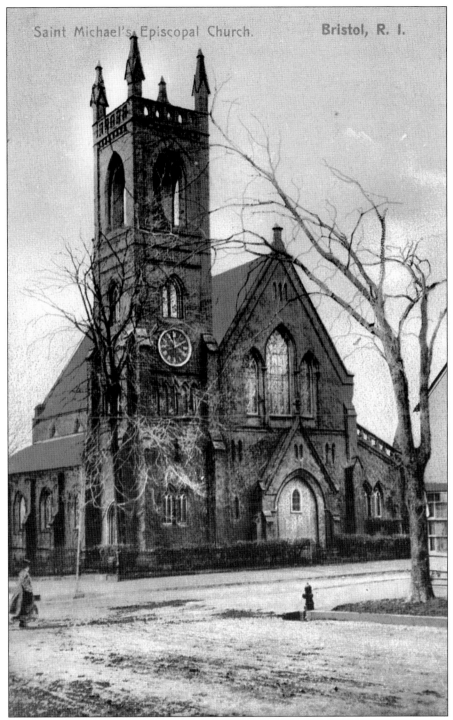

ST. MICHAEL'S EPISCOPAL CHURCH. In this *c.* 1915 photograph we can clearly see the belfry that replaced the spire. This is the fourth church structure built on the site of the original church. George Ricker of Newark, New Jersey, constructed this, the current church edifice, in 1860 from plans by Saeltzer and Valk of New York.

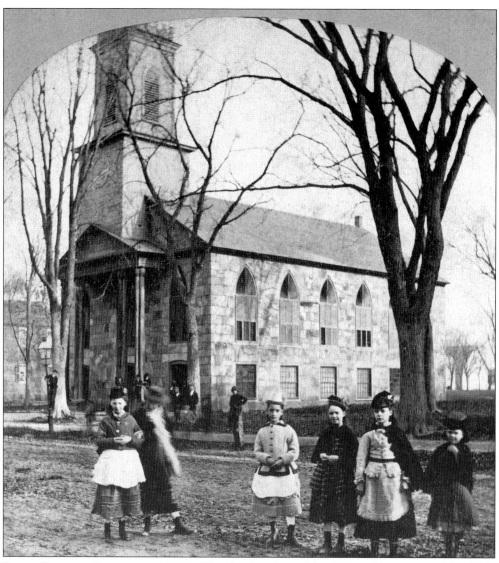

FIRST BAPTIST CHURCH, C. 1880. The Baptists formed in 1811 and incorporated in 1812. In 1814, the town granted the congregation the privilege of erecting a meetinghouse on the common. Known as the Baptist Stone Chapel, it is a two-story, gable-roof Federal dominated by a shallow, projecting Ionic portico rising to a large square bell tower with corner quoins and Ionic pilasters supporting an open, arcaded octagonal cupola.

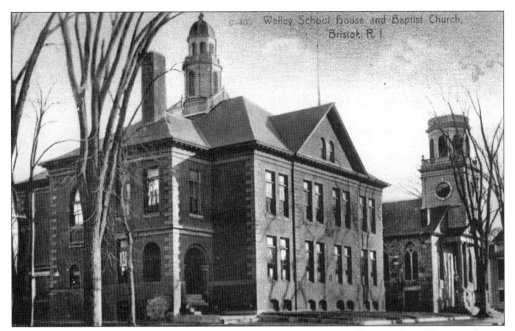

WALLEY SCHOOL AND BAPTIST CHURCH, C. 1915. The original spire of the Baptist Church was blown off in the Great Gale of 1869; it was never rebuilt. In this image, we have an unobstructed view of the belfry's clipped tower.

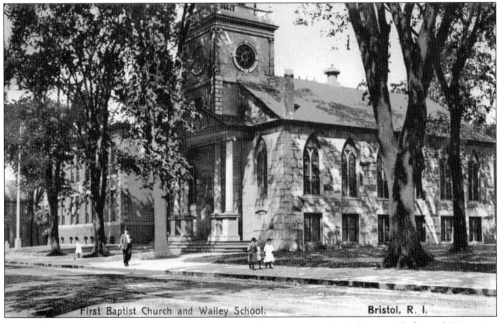

FIRST BAPTIST CHURCH, C. 1920. In 1882, Gothic compound windows with frosted Victorian glass were installed. Twentieth century installations included an iron fence with spiked balusters and modern lighting. This is the oldest church building in Bristol that is still in use.

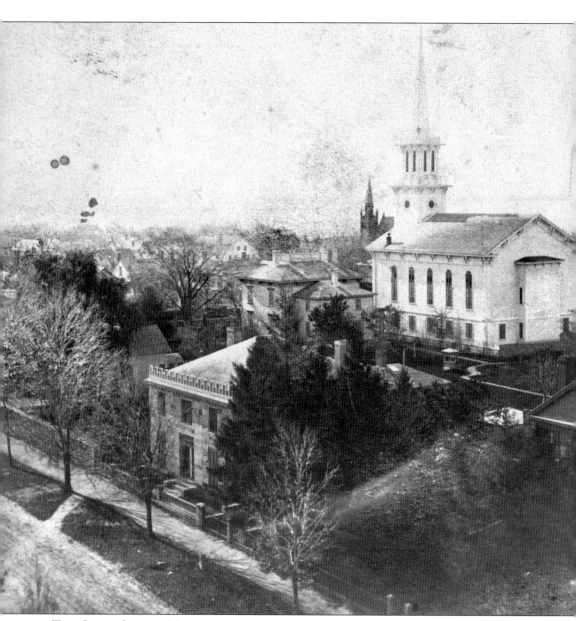

THE STATE STREET METHODIST EPISCOPAL CHURCH, C. 1885. This is a bird's eye view of the edifice, with High Street and the stone barn built in 1824 for James DeWolf and later remodeled by Russell Warren as a dwelling in the foreground. At the time this photograph was taken, the spire of the State Street ME Church was the highest point in town. The photograph must have been taken from the tower of the Congregational church.

INTERIOR OF THE STATE STREET METHODIST EPISCOPAL CHURCH, C. 1880. The church contained 120 pews and side galleries containing 12 additional pews each. The pews, galleries, and orchestra, which contained a $1,500 organ, were grained in rich oak color. The black walnut pulpit was hand carved by John S. Weeden and is said to have been a work of art. A terrible scandal involving a minister of this church concerned murder.

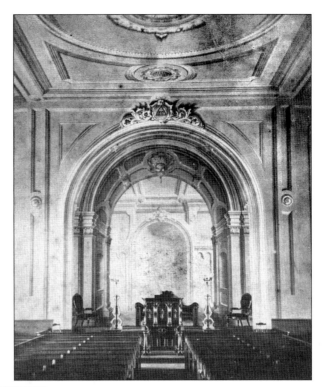

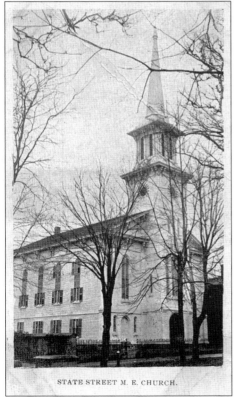

STATE STREET M. E. CHURCH.

THE STATE STREET METHODIST EPISCOPAL CHURCH, C. 1925. The edifice was an outstanding Colonial form with Italianate details. The building was designed by Providence architect Perez Mason. The structure lasted for 83 years until the hurricane of 1938, when the building's soaring tower fell through the roof, demolishing the magnificent sanctuary.

THE OLD BRADFORD STREET CONGREGATIONAL CHURCH BUILDING. This *c.* 1920 image shows the old Congregational church in one of its reincarnations. The building served the town in many capacities. Bristolians no longer walk the town's streets who remember when this building was a school, an opera house, movie theater, or town hall. After a fire destroyed the original 1784 structure in 1934, the existing Art Deco theater was built.

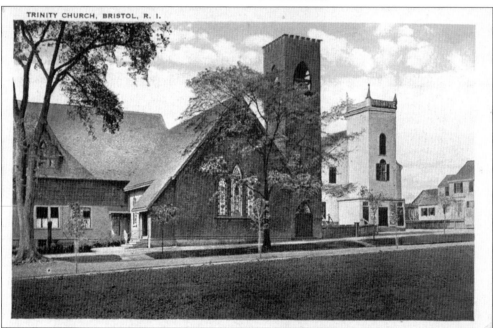

TRINITY EPISCOPAL CHURCH, c. 1920. Fronting on Bradford Street, Trinity church was erected in 1877, with funds from the estate of Ruth B. DeWolf. DeWolf's 1784, two-and-a-half-story, brick Federal-style home on the corner of Bradford and Hope Streets became the rectory for the new church. In the 1930s, both structures were torn down to construct the Andrews School. For the sake of a school, Bristol lost a magnificent Federal-period building.

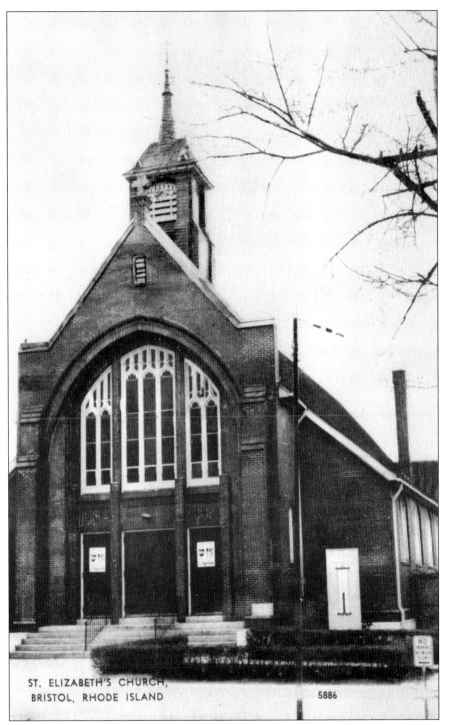

ST. ELIZABETH'S CHURCH,
BRISTOL, RHODE ISLAND

5886

ST. ELIZABETH CATHOLIC CHURCH C. 1930. Architects Murphy, Hindle and White designed this one-and-a-half-story, red brick, end-gable-roof church, with hip roof pinnacle belfry for a Portuguese-American parish of about 3,000 people. A restoration of the steeple and belfry, and construction of an elaborate glass-roofed and pillared entrance, were completed in 2005.

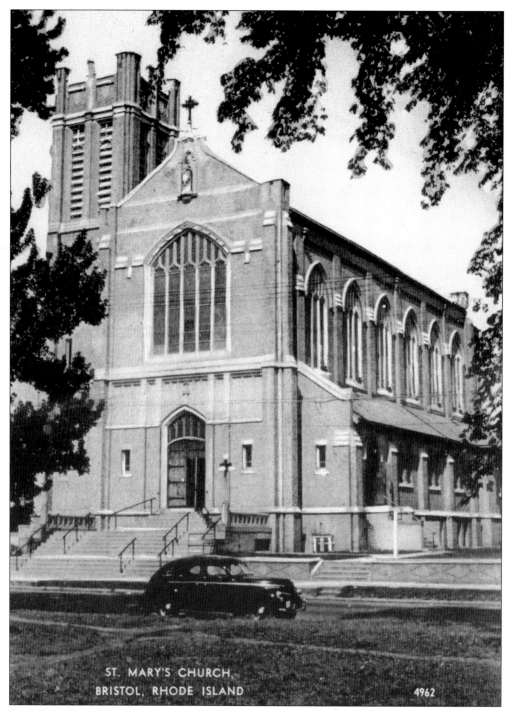

ST. MARY'S CHURCH,
BRISTOL, RHODE ISLAND
4962

ST. MARY CATHOLIC CHURCH, C. 1945. This two-story, gable roof Norman Gothic Revival church is steel framed with buff brick and limestone facing. The building is especially noted for its 51 leaded and stained art glass windows depicting the life of Christ by Franz Mayer of Munich, Incorporated.

Seven

Mount Hope, King Philip, and The Narrows

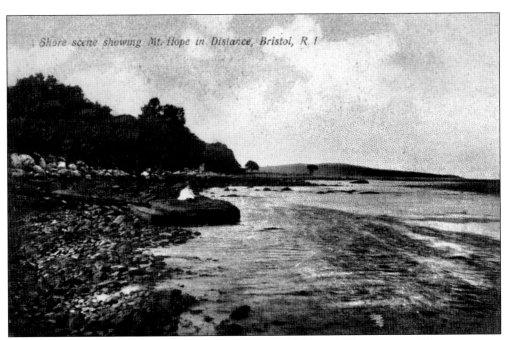

The Bristol Shore of Mount Hope Bay with Mount Hope in the Background, c. 1910. Before the rampant commercial and residential development of the Mount Hope Lands in the mid- to late-20th century, Mount Hope Bay teemed with fin and shellfish in its sparkling clean waters.

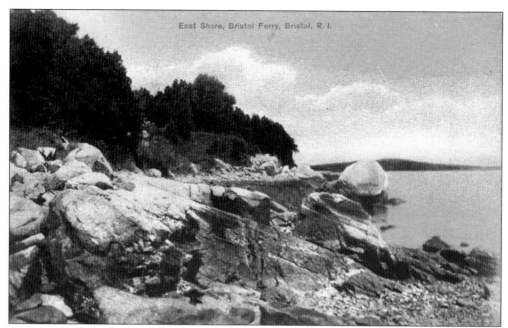

THE BRISTOL SHORE OF MOUNT HOPE BAY WITH MOUNT HOPE IN THE BACKGROUND, *c.* **1910.** Here one can see a rugged section on Bristol's east shore in the vicinity of the so-called Viking rock.

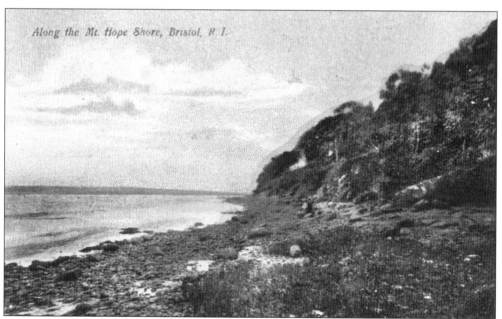

MOUNT HOPE BAY WITH MOUNT HOPE IN THE BACKGROUND, *c.* **1910.** This is the view west from the stony shore of Mount Hope Bay with the craggy foothill of Mount Hope beckoning. In the mid-1950s, only inches under those sea-washed stones were bushels of succulent soft shell clams, free for the picking. It is regrettable that pollution and over harvesting has nearly depleted the species.

Tower Road, c. 1910. Crossing the verdant foothills to Mount Hope at the beginning of the 20th century is unlike the same journey taken today. Today these same acres are dense with second and third growth forest. During the mid-19th century, the Mount Hope lands were stripped of their first growth timber for the construction of ships, homes, and mills. The vacant land was then converted to cultivation of produce.

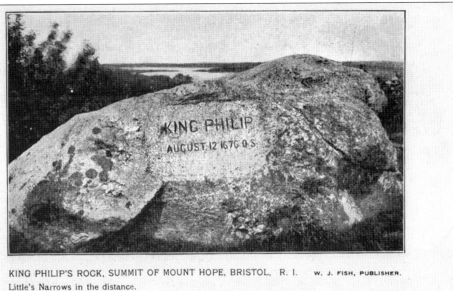

KING PHILIP'S ROCK, SUMMIT OF MOUNT HOPE, BRISTOL, R. I. W. J. FISH, PUBLISHER.
Little's Narrows in the distance.

King Philip's Rock at the Summit of Mount Hope, c. 1905. On August 12, 1676, a Seaconnet Wampanoag Indian attacked and murdered King Philip at the cold spring on Mount Hope. The longest, bloodiest, and least chivalric war that the colonists had waged with the American Indians, mostly at the hands of Massachusetts and Connecticut whites and their Native American allies, came to its tragic end.

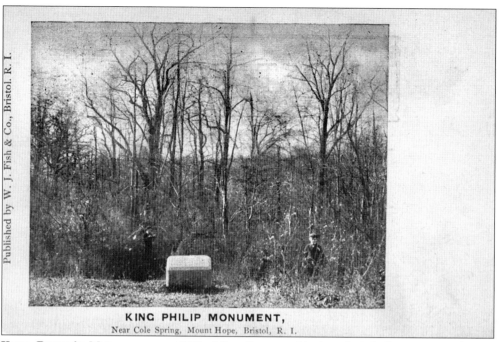

Published by W. J. Fish & Co., Bristol. R. I.

KING PHILIP MONUMENT,
Near Cole Spring, Mount Hope, Bristol, R. I.

KING PHILIP'S MEMORIAL, C. 1915. Like all wars with America's indigenous people, the tale of King Philip's War is filled with strange mixtures of barbarism and heroism; the Indian warrior often rising in the pursuit of his ideal to a moral grandeur that his "civilized" antagonist failed to attain.

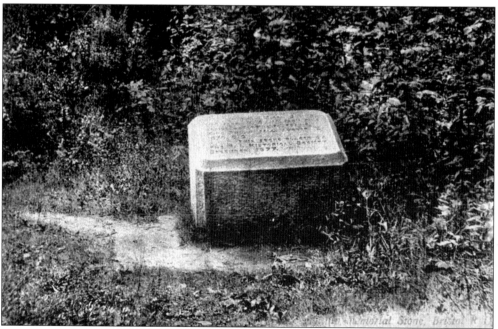

KING PHILIP'S MEMORIAL, C. 1909. The legend on the memorial tablet reads: "In the 'Miery Swamp' 100 feet WSW from this spring, according to tradition, King Philip fell August 12, 1676, OS. This stone placed by the RI Historical Society December 1877."

108

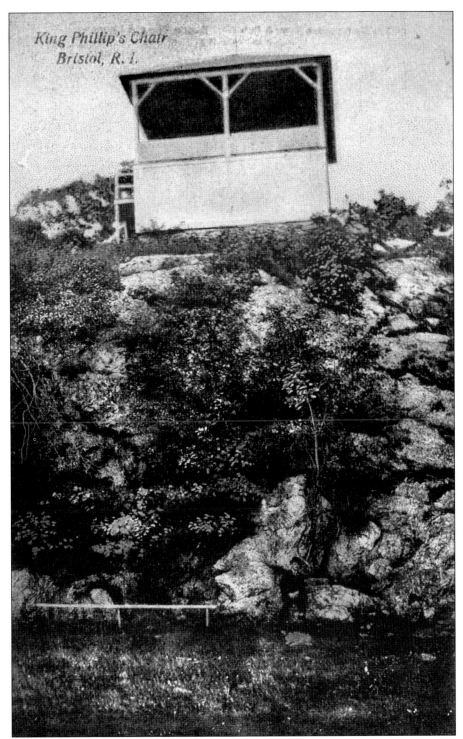

KING PHILIP'S THRONE, C. 1909. A Boy Scout observation tower was built on the brow of Mount Hope's stony wall. The tower is constructed over King Philip's throne, a cozy natural chair-like niche in the in the rock-strewn hillside.

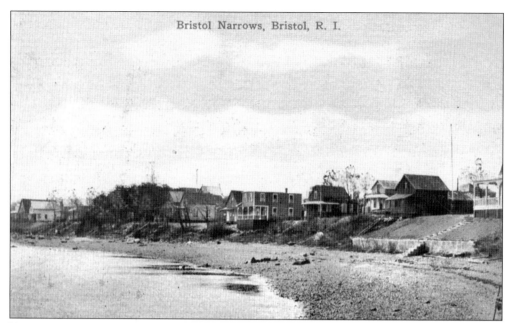

Bristol Narrows, Bristol, R. I.

THE SUMMER COLONY AT BRISTOL NARROWS, C. 1910. The Narrows is located at the northeast shoulder of Mount Hope where the Kickamuit River empties into Mount Hope Bay at the Bay's western branch, a short distance across the water from Touisset Point in Warren, Rhode Island.

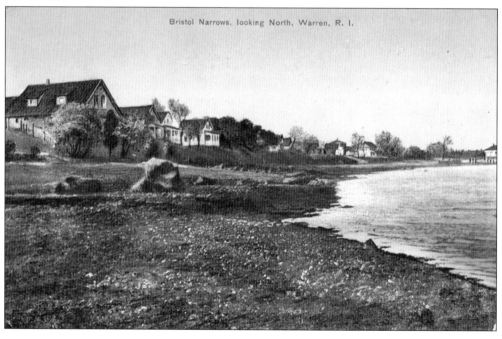

Bristol Narrows, looking North, Warren, R. I.

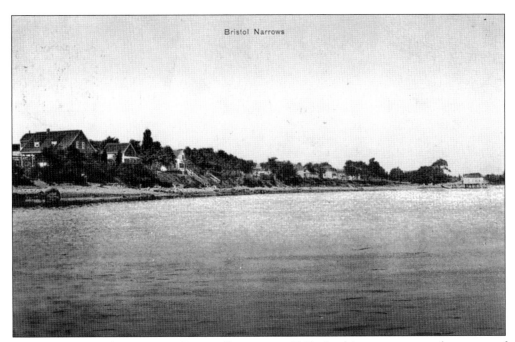

Bristol Narrows

THE COTTAGES ABOVE THE STONY BEACH, C. 1910. In this narrow span, the waters of Mount Hope Bay are placid with moderate waves making it ideal for small boats and the casting for game fish from the gently slopping shore.

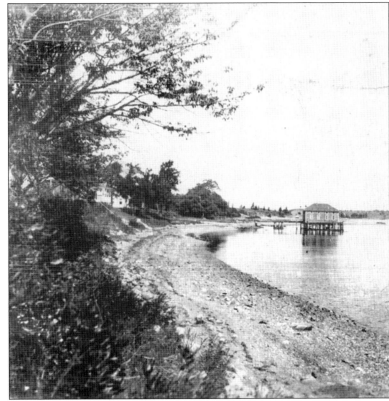

THE ODD HOUSE ON STILTS, C. 1919. It is difficult not to be intrigued by the odd house on stilts, in the water, at the curve in the beach.

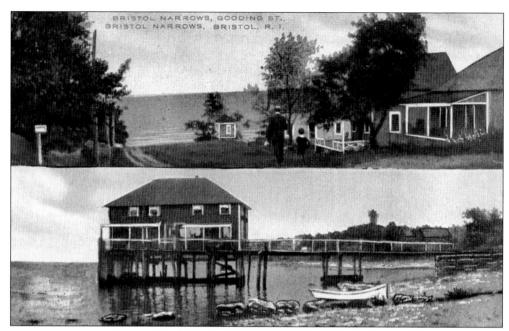

THE VIEW EAST OF THE SUMMER COTTAGES ALONG UNPAVED NARROWS ROAD, C. **1919.** Except for the disappearance of the house on stilts, little has changed in this wide and welcoming access to the shore.

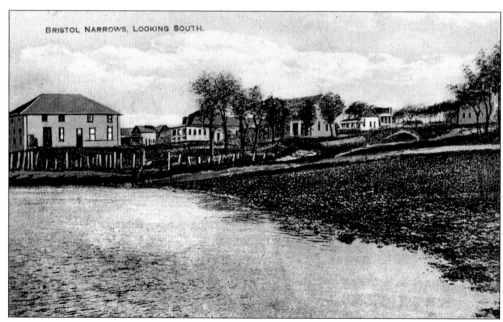

ON THE PEBBLY NARROWS BEACH LOOKING WEST UP NARROWS ROAD, C. **1915.** In a recent partnership between citizens, town government, and Pokanoket Wampanoag Indians, some 30 acres of woodland were saved from development. This wilderness will be preserved in its natural state for passive recreation and as a wild life reservation.

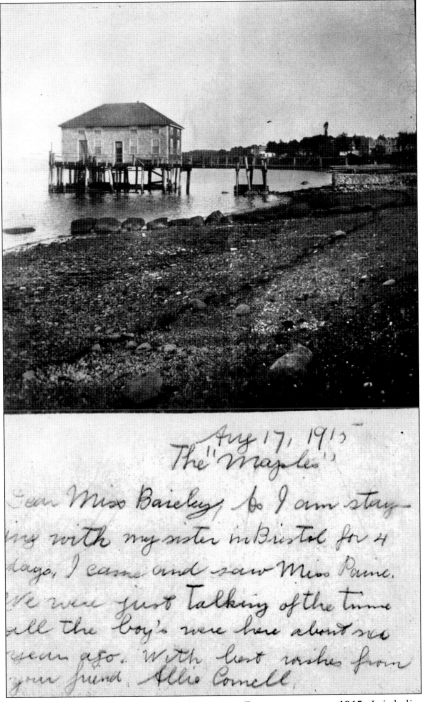

THE SITE OF KING PHILIP'S PRIMARY VILLAGE, POKANOKET, C. 1915. It is believed that Philip's principle summer village was located here, south of Sowams (Warren), on the eastern side of the Mount Hope peninsula, at the Narrows (called Pokanoket) in present-day Bristol. Pokanoket looks directly across to nearby Touisset Point, just south of the English settlement in Swansea, Massachusetts.

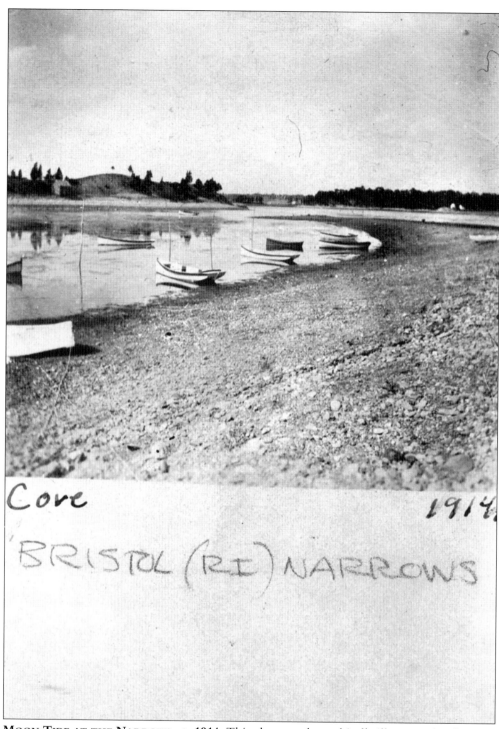

Core 1914

BRISTOL (RI) NARROWS

MOON TIDE AT THE NARROWS, C. 1914. This photograph graphically illustrates the closeness of the Bristol shore to that of Warren's Touisset Point. Writing in 1845, historian Guy Fessenden claimed he had located the remains of the fort built by the colonial army on or near this site after Philip had abandoned it. By 1906, the sea had eroded the site completely.

Eight

HERE, THERE, AND ALL AROUND TOWN

ONIONS, GEESE, AND GIRLS. Bristol, a bustling and thriving port of call was known for its, "onions, geese, and girls."

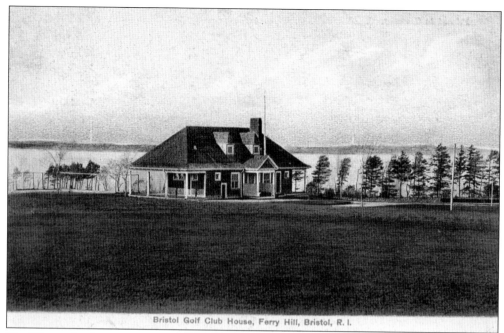

Bristol Golf Club House, Ferry Hill, Bristol, R. I.

VANWICKLE'S GOLF CLUB, c. 1908. According to Alice DeWolf Pardee in her 1976 book *Blithewold*, in 1897, VanWickle and three neighbors whose property abutted his, Dr. Howe and Messrs. Mills, and Low, formed the Ferry Hill Improvement Company, known generally as the Golf Club. Each of these gentlemen contributed a piece of their land, upon which was built a nine-hole golf course, a tennis court, and a small clubhouse.

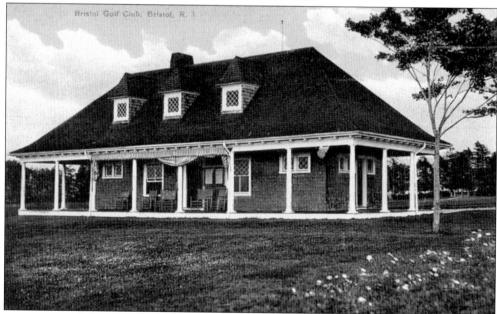

Bristol Golf Club, Bristol, R. I.

VANWICKLE'S GOLF CLUBHOUSE, c. 1908. The exact location of the clubhouse in relation to the mansion cannot be determined by these postcard images. However, it was located on a knoll overlooking the Blithewold dock. The property that once was the golf course is now owned by the Columban Missionaries.

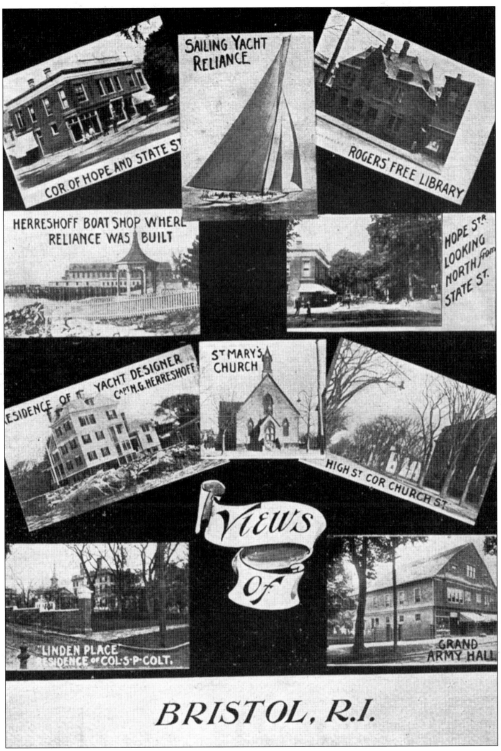

POSTCARD IMAGES OF BRISTOL, *C.* 1905. This is a handy reference of a series of photos published by the Anglo-American Post Card Company, 2 West Fourteenth Street, New York.

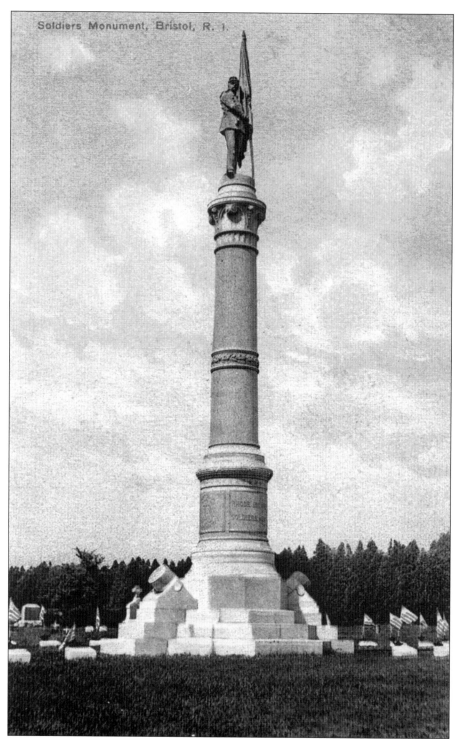

CIVIL WAR MONUMENT, C. 1915. In the Rhode Island Historical Cemetery, a monumental column of composite stone is shown surmounted by a bronze statue of a Union Soldier holding Old Glory and a sword.

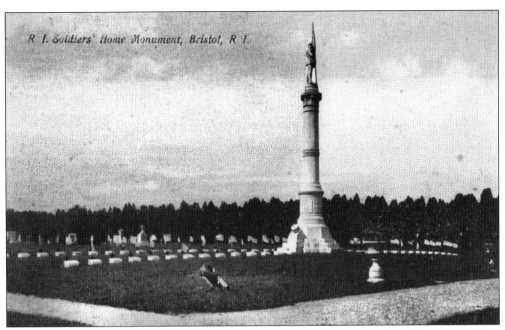

CIVIL WAR MONUMENT, C. 1915. The base of the monument is decorated with representations of Civil War mortars. The monument was erected by the State of Rhode Island, and stands amid the graves of Civil War veterans.

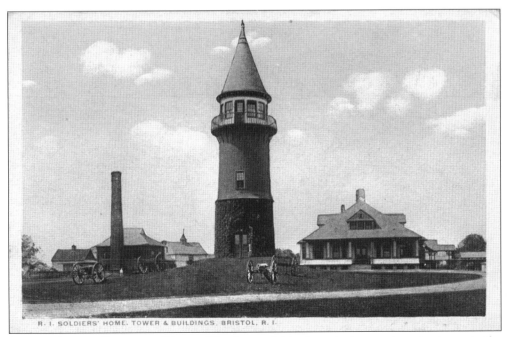

RHODE ISLAND VETERANS HOME. The focus of this photo is the ornate water tower in the appearance of a lighthouse on the grounds of the Rhode Island Veteran's Home. For a concise history of the home, see *Bristol: Montaup to Poppasquash*, Arcadia Publishing, 2002.

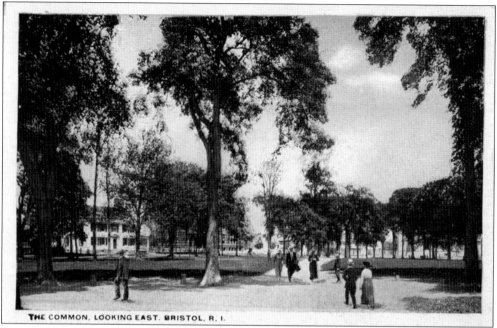

THE COMMON. LOOKING EAST. BRISTOL. R. I.

THE TOWN COMMON, C. 1920. The Grand Articles of 1680 set off one eight-acre square for a town common. From 1681 to 1698, a militia formed to protect against Native Americans. Under Capt. Benjamin Church the militia drilled and paraded on the common every Saturday. Burials near the site of the present courthouse began in 1718. These grave markers were later removed to the East Burying Ground, but the graves were left undisturbed.

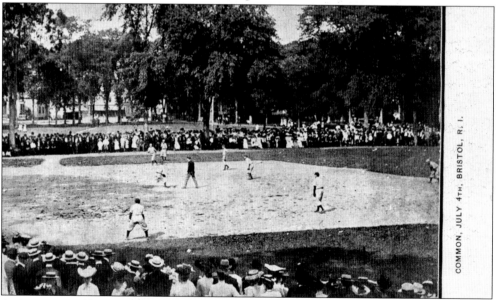

COMMON, JULY 4TH, BRISTOL, R. I.

A 4TH OF JULY BALL GAME ON THE COMMON, C. 1915. The development of Bristol Common reflects the changing attitudes of citizens in the construction of a variety of religious, educational, and political structures as well as the introduction of various sporting and entertainment venues. Every July for over 150 years a carnival has been set up on the common; today, there are regularly scheduled summer concerts that are free to all.

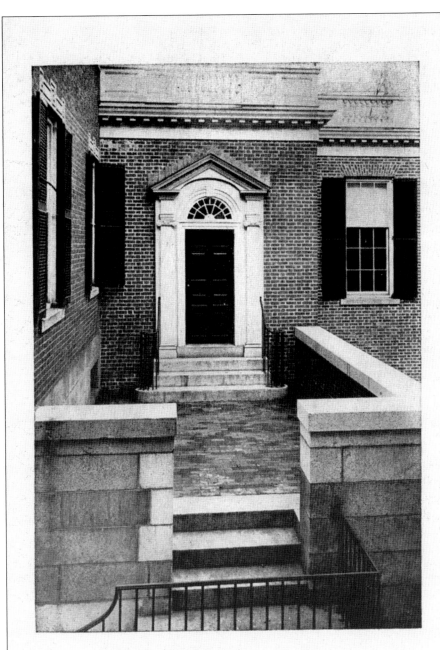

RHODE ISLAND SCHOOL OF DESIGN
EARLY AMERICAN DOORWAY FROM BRISTOL, R. I.

AN ELEGANT COLONIAL-ERA DOORWAY. The magnificent Greek Revival entrance surrounded with engaged columns and fanlight saved from a razed Bristol home now graces the façade of a building at the Rhode Island School of Design.

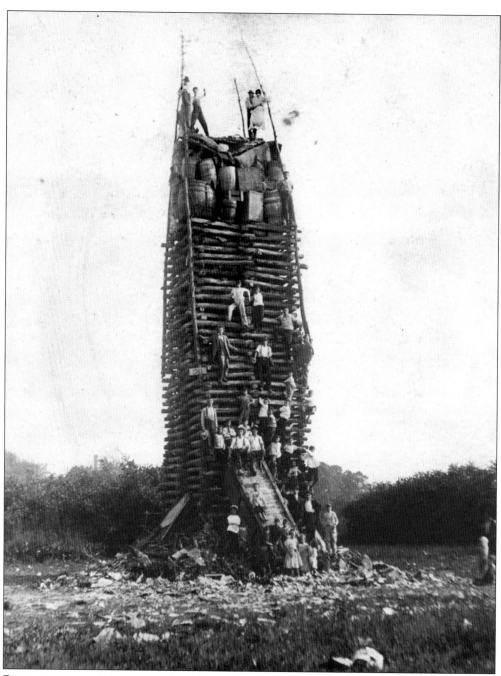

PREPARING THE FOURTH OF JULY BONFIRE, 1911. The annals of Bristol's Fourth of July celebrations are regaled with stories of official and unofficial bonfires. The old Wood Street dump was a popular spot for the conflagration. The neighborhood boys (and a few girls) take pride in their construction of old railroad ties and tar-soaked barrels as they pose for the photographer. Someone had the presence of mind to post a sign with the year on the pile.

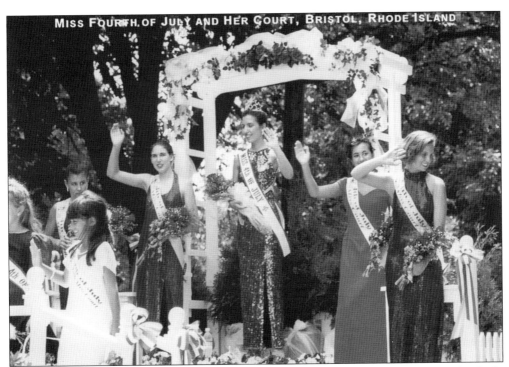

MISS FOURTH OF JULY PARADE FLOAT, 1998. Each year since 1948 the Miss Fourth of July pageant has drawn dozens of Bristol's young women to vie for the coveted diadem and to reign over the town's celebration and the Civic, Military, and Fireman's parade.

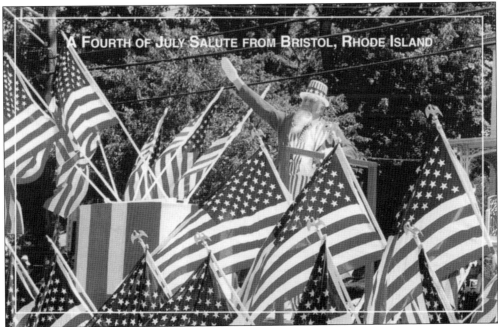

BRISTOL IS THE MOST PATRIOTIC TOWN IN THE COUNTRY, 1996. Every July 4 since 1785, Bristol has celebrated Independence Day. It is the longest continual Fourth of July celebration in the country.

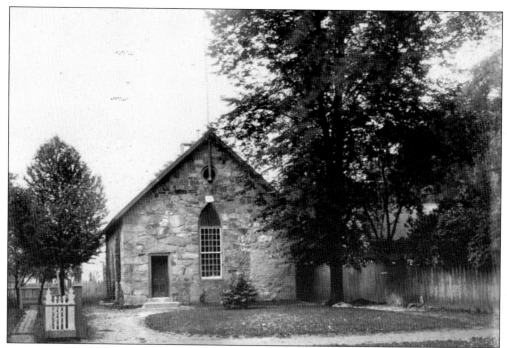

THE ONE-ROOM STONE BURTON SCHOOL ON HIGH STREET, C. 1890. With the advent of modern multi-storied brick school buildings, the old stone schoolhouse was leased to the United Rubber Workers as a union hall. Later other town committees met there, including the Fourth of July Committee. The building, now enlarged and modernized, is a private residence.

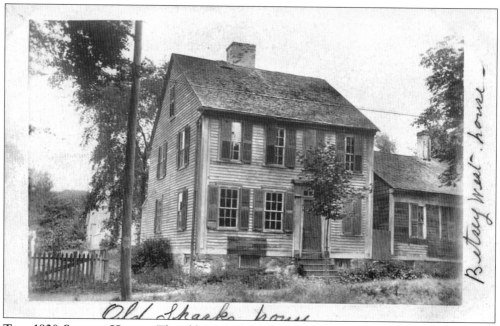

THE 1820 SPARKS HOUSE. The old Sparks house, also known as the Betsey West house, at 55 Constitutions Street, is a four-bay, two-and-a-half-story, center chimney residence in the Federal style.

L. N. Colwell's Bungalow, "Idalou," at Bristol Highlands, c. 1914. Before the Highlands became the crowded, compact neighborhood that it is today, the area contained many large tracts with summer cottages situated to catch the cooling breezes off of Narragansett Bay.

The Home of Miss Mary Munroe at 23 Summer Street, c. 1930. This one-and-a-half story, 2 bay cottage in the generic style is typical of Bristol's blue collar homes built in the compact area of town during the first half of the 1900s.

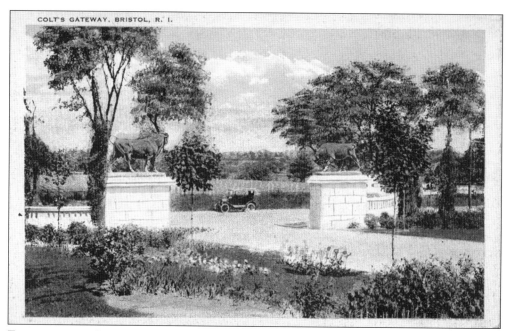

ENTRANCE TO COLONEL COLT'S FARM, *C.* 1925. During the first quarter of the 1900s, this Hope Street entrance to Colonel Colt's farm was out in the country. Most Bristolians will be hard pressed to remember when this northern section of town was pastoral.

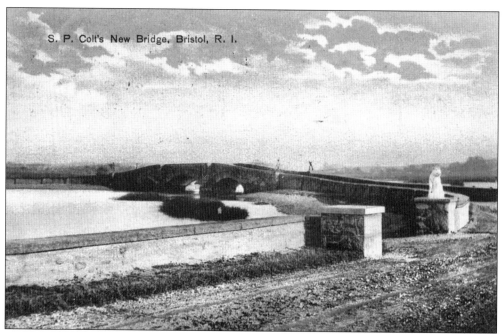

COLT'S MILL GUT BRIDGE, *C.* 1910. Colonel Colt spanned the gut inlet from Narragansett Bay with this hand-laid free stone arched bridge. With rambling acres of pasture and woodland, Colt State Park is the jewel of Rhode Island's public parks on the Narragansett Bay. Colt acquired the farm at the beginning of the 20th century with the intention to preserve it and allow the public free access.

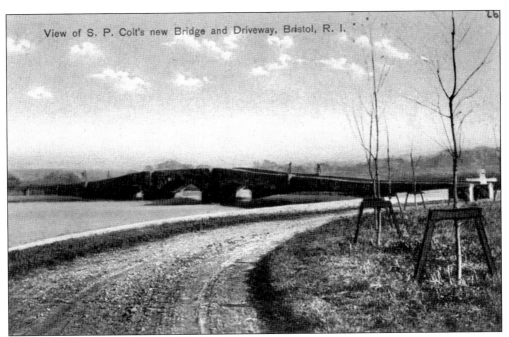

View of S. P. Colt's new Bridge and Driveway, Bristol, R. I.

COLONEL COLT. Colonel Colt had a large sculpture collection and his magnificent park's bridges and shore-drive were decorated with marble statues of Roman and Greek deities, including those of Diana and Venus, in order to enrich the lives of visitors. So enriched were the visitors that they often spoke of the Colonel's bulls, boars, and "bares." In 1965, these lands were secured to be part of the state's park system, fulfilling Colt's wish that the public always have free access to his former seaside estate.

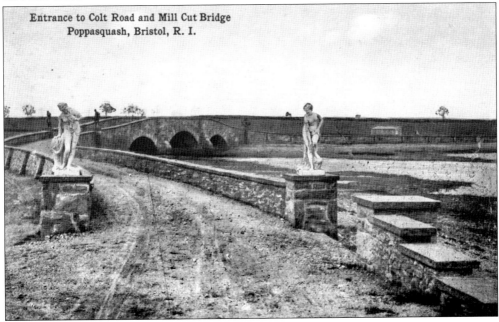

Entrance to Colt Road and Mill Cut Bridge
Poppasquash, Bristol, R. I.

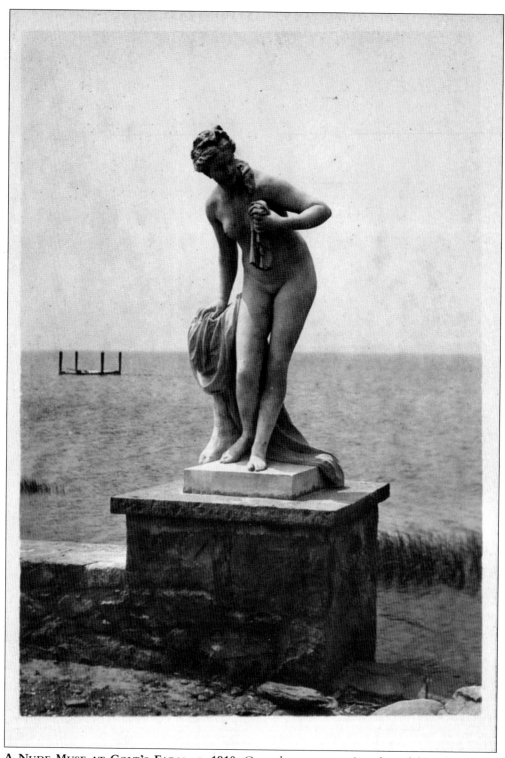

A Nude Muse at Colt's Farm, c. 1910. Over the years, continued vandalism forced the removal of all portable sculptures to storage at Linden place.